PAINTING WITH LIGHT:
A Centennial History of the Judson Studios

Painting with Light: A Centennial History of the Judson Studios by Jane Apostol is the third in a series of publications celebrating the Sesquicentennial of California, 1846–1850. The Historical Society of Southern California is pleased to acknowledge the generous support of the J. B. and Emily Van Nuys Charities in making this publication possible and in making it available to the schools of Los Angeles County.

PAINTING WITH LIGHT

A Centennial History of the Judson Studios

BY JANE APOSTOL

HISTORICAL SOCIETY OF SOUTHERN CALIFORNIA
Los Angeles, California
1997

Contents

Illustrations

PAINTING WITH LIGHT

Foreword

Years ago I was walking through a Pasadena house with its architect, Alfred Heineman. It was a fine Arts and Crafts house dating from about 1909 and was full of magnificent art glass. I asked Alfred whether he designed his own art glass or did he depend on a catalog. "Oh, I always designed my own glass, and then I had it fabricated by a funny little studio on the Arroyo Seco in Garvanza. I've forgotten its name." "Judson?" I suggested. "How did you know that?" he asked. "Why, because it still exists," I laughed.

Alfred did not have a good memory in his age (he was 90 when we made the visit) and may have been confused about the circumstances of his commission. Jane Apostol's always correct dates in this book show that the W. H. Judson Art Glass Company did not move from downtown Los Angeles to Garvanza until 1920, long after Alfred had designed his last Arts and Crafts house. Nevertheless, W. H. Judson, the founder of The Judson Studios, was a member of the Arroyo Guild of Fellow Craftsmen that in 1909 was housed at 200 South Avenue 66 in Garvanza, where he later moved his company. His father, William Lees Judson, owned the guild-hall, and W. H. could have done some work there, or at least picked up Alfred Heineman's order there. The story should be true! Alfred never made up stories.

About the Guild: my friends realize by now that I get my greatest inspirations from looking at buildings. When I joined the Occidental College faculty in 1963, someone told me about a rather Islamic looking building on Avenue 66 just below York Boulevard. I checked it out, and it was, of course, the Judson Studios. Then I found a copy of the one and only issue of *The Arroyo Craftsman* published in October of 1909 by the Arroyo Guild of Fellow Craftsman who were located at the same address as the present studios. As a student of the American Arts and Crafts movement I was thrilled to find out here in California a journal and organization devoted to the ideas of William Morris, the English reformer and founder of the movement. Indeed, this issue was dedicated to his memory and to his goal of reviving hand-craftsmanship.

I looked forward to finding a copy of the following issue which was to be devoted to a presentation of the ideas of Gustav Stickley, the American promoter of Morris's faith. It would undoubtedly have been edited by George Wharton James, who with William Lees Judson had founded the Guild and was the western correspondent for Stickley's *The Craftsman* magazine. In spite of the Guild's motto "We Can," the promised next issue of *The Arroyo Craftsman* never appeared.

Along with the magazine other records of the Arroyo Guild seem to have disappeared. In fact the paucity of information on the Guild has brought on one of the biggest frustrations in my otherwise problem-free life. Like many self-aggrandizing teachers, I have sent students to do the work that I should do myself. Every time they have come back from Garvanza empty-handed.

FOREWORD

Even Garvanza has all but disappeared into the vastness of Highland Park with only a few, aged store signs to show us the site of what was once the artistic center of Los Angeles. One institution remains to remind us of its once lively culture: that "funny little studio on the Arroyo in Garvanza," the Judson Glass Company about which this fine book is a study. As you will see, Judson is still going strong.

ROBERT WINTER
Occidental College

(Facing page) William Lees Judson, plein-air painter and
founding dean of the School of Fine Arts of
the University of Southern California.

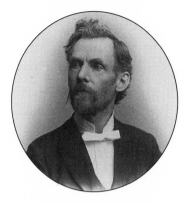

I
William Lees Judson

Pick up anywhere a decaying twig, a mossy stone or a withered leaf. Look into the intricacies of its texture, the manifold gradations of its every changing surface. Each square inch is a complete color scheme, a sufficient basis for a picture.
———*William Lees Judson, 1902*

William Lees Judson, an award-winning artist and influential teacher, inspired several generations of students and instilled in his own family an appreciation of beauty and the creative process–a legacy his children passed on to their children and grandchildren. That legacy has a tangible presence today in The Judson Studios, artisans of stained glass, faceted glass, and mosaics. For one hundred years a favorite saying of William Lees Judson has guided the Studios: "Only the best is worthwhile."

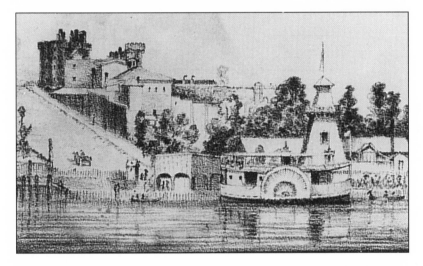

One of W. L. Judson's pencil sketches illustrating his book, *A Tour of the Thames*. The scene depicted is in London, Ontario.

Judson was born on April 1, 1842, in Manchester, England, and came to the United States in 1854. "Practiced art from my earliest recollection; Father and Grandfather having been artists," he wrote in tantalizingly brief notes for the Los Angeles Public Library. His father, John Randle Judson, had apprenticed in the decorative arts, including stained glass; and he was manager of a cotton mill in Ashton-under-Lyne, Lancashire. When strikers burned down the mill in 1852, John Randle Judson left England to seek employment in the United States. He found work as a decorator in Ohio and New York, then turned to farming. In 1854 his wife, Ann, and their five children joined him in Brooklyn, where William Lees Judson attended public school and studied art under his father. In 1857 the family settled in Western Canada, on the peninsula between Lakes Huron and Erie. Their first home was in London, Ontario, the center of a rich agricultural area. In 1860 they moved fifty miles away to the village of Thamesville, which takes its name from the river on which it is located.

A journal begun by William Lees Judson on his eighteenth birthday provides glimpses of his first year in Thamesville. For a few months he worked as a store clerk, and occasionally he had jobs painting a wagon or a buggy. He faithfully attended Methodist church services, taught Sunday School, and took part in temperance meetings. He had livelier interests as well: swimming, boating, hunting, hiking, playing the violin, and singing. "Evening met to practice the Music at Sherman's," reads one cheerful entry. "Plenty of Girls and any quantity of fun. Enjoyed myself very well."

The Civil War service medal presented to William Lees Judson by the widow of Ulysses S. Grant. Judson served under Grant in the 21st Illinois volunteers.

In August 1860 Judson left Canada for a visit to the United States. Traveling through the Great Lakes region, he sketched the landscape and worked at odd jobs as a painter. He found much to entertain him, including concerts, book auctions, and a grand torchlight parade celebrating the election of Abraham Lincoln. In Columbus he entered into a partnership to paint a grand panorama of the Wonders of the World. Unfortunately, the curtains caught fire on opening night, the enterprise was ruined, and Judson had to leave his violin as security for payment of his room and board.

At the outbreak of the Civil War, Judson was in Illinois and he promptly enlisted in the 21st Illinois Volunteers, whose commanding officer was Ulysses S. Grant. Judson played in the regimental band and served in the commissary department, eventually becoming chief clerk at 20th Army Corps headquarters. Although his term of enlistment was up in 1864, he continued as chief clerk until the war ended in 1865.

Judson's wartime diary is now in the Smithsonian Institution's Archives of American Art. The entries are disappointingly brief, as he himself observed years later. "It astonishes me now that I have given so few details of these interesting times," he wrote. "The few hints here given remind of incidents enough to fill a volume." There are laconic references to guard duty, long marches, occasional combat, and frequent illness. There is mention also of pleasant diversions: rafting on a river, "geologizing," attending a play, or enjoying the happy purchase of a carpetbag of books. On some pages of the diary Judson made small pencil sketches of faces, animals, or scenery. Once he was so absorbed in sketching

An amusing scene sketched by W. L. Judson during a trip
down the Thames River in Canada. He defined tourists as
people who never enjoyed themselves because they were
too busy looking for everything listed in the guidebook.

the landscape that he missed roll call "and being absent was placed under guard with 200 others."

Upon returning to Canada in 1865, Judson engaged in farming and cattle raising–occupations he soon abandoned for a career in art. Despite the financial hardships this entailed, he was encouraged to proceed by his devoted wife, Maria Bedford, whom he had married in 1868. At that time his jobs in the field of art ranged from striping wagons to working in stained glass. From 1872 to 1873 he studied in New York with genre and portrait painter John B. Irving, and in 1874 Judson opened his own portrait studio in London, Ontario. After viewing the landmark exhibition of art at the International Exposition in Philadelphia in 1876, he was eager to pursue art studies abroad. From 1878 to 1881 Judson attended the Académie Julian in Paris. His wife remained in Canada, managing the household and caring for their six children.

In 1881 Judson became professor of the art department at Hellmuth College in Ontario. That year he also published his first book, a lively account of adventuring by skiff down the Canadian river Thames. He made many charming pencil sketches for the book, whose title page reads: *A Tour of the Thames. Written and Illustrated with a Faber's B.B. by Professor Blot.*

Maria Judson died in 1885, soon after the birth of her seventh child. Judson remained in Canada for five more years, teaching and painting. (He also added to his family, adopting an orphaned nephew in 1888.) "Then came the announcement of the great and wonderful fair to be held in Chicago," wrote author and lecturer George Wharton James. "The lure of its art possibilities seized

A view of the Arroyo Seco before it was paved as a flood control channel. The turreted house built by W. L. Judson can be seen at the left. *Courtesy of Emily Rundstrom Wilson.*

upon Mr. Judson and he resolved to go and take advantage of them." In 1890 he auctioned all his work and left for Chicago. A farewell letter from Methodist church leaders expressed appreciation for his teaching in Sabbath School "and using also the talent God has given you as an artist in placing on the blackboard illustrated teachings of the S. S. lessons."

During the three years before the opening of the World's Columbian Exposition, Judson read and studied, prepared work he hoped to exhibit, and supported himself by painting portraits and helping with organization of the fair. Because overwork and the rigors of the climate shattered his health, he was advised to move to a warmer climate and to rest.

George Wharton James, who had met Judson in Chicago, persuaded him to move to Southern California, where he himself had settled. At the age of fifty-one, "slight and frail-looking," Judson left for Los Angeles, accompanied by his two youngest daughters. "He arrived here in broken health and penniless, where there was no market and little desire for art," James recalled. "Two days later, in December 1893, the eyes of the artist first saw the beautiful Arroyo Seco. It was love at first sight, and the banks of the Arroyo, in the Highlands, became his home for the rest of his life."

The Arroyo Seco is the usually dry watercourse originating in the San Gabriel Mountains above Pasadena and extending to the Los Angeles River. Now a paved flood control channel for much of its length, in Judson's day it was a picturesque stream bed shaded by willows and sycamores and edged with ferns and wildflowers. On a bluff overlooking the Arroyo, Judson built a two-story stonework and shingle house

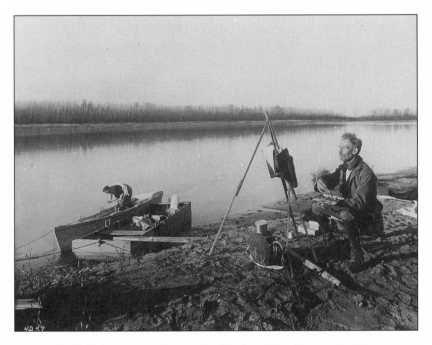

W. L. Judson painting on the banks of the Colorado River.
The photograph was taken by George Wharton James
during an expedition from Yuma to the Salton Sea.
Courtesy of Huntington Library.

of his own design. It was located about four and a half miles northeast of downtown Los Angeles, in the Highland Park area known at the time as Garvanza because of the garbanzo beans planted on the hillsides when they were part of the great Rancho San Rafael. (In 1997 residents petitioned for restoration of the historic name of Garvanza.)

After settling in California, Judson had quickly resumed his art career. He gave lessons in his home and also taught at the Los Angeles School of Art and Design, the most important private art school in the Los Angeles area. Before coming to the West Coast, Judson was known chiefly as a portrait painter. Inspired by the California landscape, however, he turned with enthusiasm to painting scenes of mountains, valleys, the desert, and the seashore; and he portrayed the Arroyo in every season. He also painted scenes of Mission days and of pastoral California. He wrote about mission architecture in a journal published by the Historical Society of Southern California, the venerable organization that he headed for one year.

Judson went on several expeditions with George Wharton James, who wrote an admiring account of the plein-air artist at work. Describing a journey the two friends took down the Colorado River, James said of Judson:

While the landing was being made he was preparing his easel, his canvas and his colors and in less time than it takes me to tell it he was the first man ashore, easel up, paint-box opened and brushes in hand, making his sketch of clump of trees, Indians "poling" up the river, the glowing desert sun-

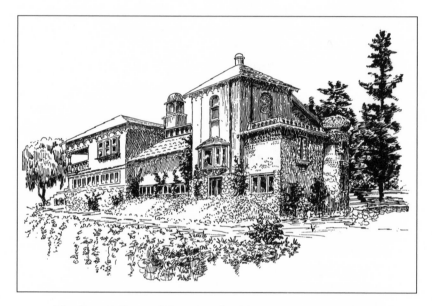

The first College of Fine Arts building. Judson established
the school in 1901 on the west bank of the Arroyo Seco,
across the street from his own home.

sets or the flood of color which deluged the desert mountains
to the delight of his artistic eye.

In 1895 Judson became head of the art department of
the University of Southern California and organized a
curriculum he described as practical and thorough.
"The courses provide for the wants of architects, scien-
tific investigators, newspaper artists and correspon-
dents, machinists, designers, textile fabrics, ceramic
wares, etc.," he wrote in 1896. Under Judson's direction,
the art department evolved into a College of Fine Arts,
and he became the school's first dean. In 1901 he estab-
lished the college in Garvanza, on Avenue 66, across
from his own house. A college bulletin described the
location: "on a cliff overlooking an unspoiled natural
park, the famed Arroyo Seco, with a perennial stream
and groves of magnificent trees, rocks, cliffs, and acres
of boulders, wide stretches of oak-dotted sward, and the
snow-capped mountains closing every vista." The fine
arts building contained classrooms, studios, a woman's
dormitory, an exhibition gallery, and a camera obscura.
When a new wing was added in 1905, the art critic of
the *Los Angeles Times* observed: "There is probably no
art school west of St. Louis quite so complete in its
equipment. This is encouraging. It shows that the art
impulse is growing with our material growth and pros-
perity, and that Los Angeles may hopefully expect to be
the art center of the West at no distant day."

In 1909 the building was enlarged to provide work-
shops and studios for members of the newly organized
Arroyo Guild, "an association of expert workers who
design and make beautiful things." Judson was the first

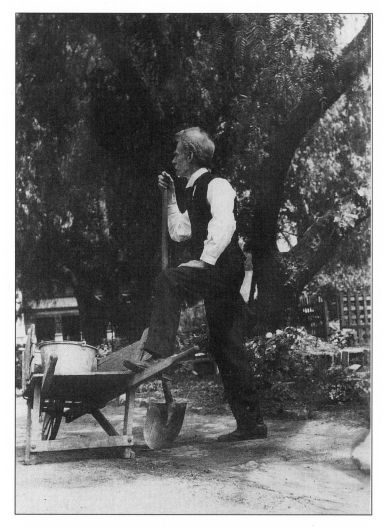

W. L. Judson pausing in his outdoor labors at the
College of Fine Arts.

president of the Guild, and George Wharton James was editor and publisher of the one and only issue of its journal, the *Arroyo Craftsman*, published in October 1909. The magazine was dedicated, said James, to "simple living, high thinking, pure democracy, genuine art, honest craftsmanship, natural inspiration, and exalted aspiration." Lectures on art, sponsored by the Guild and open to the community, were given throughout the winter months in the exhibition gallery of the fine arts building.

A disastrous fire destroyed the building and hundreds of Judson's canvases in December 1910. According to a vivid news report, "Announcement was immediately made that classes would meet as usual on Friday under the spreading peppers beside the smoking ruins, and the plucky Dean declared that lumber would be on the ground for rebuilding before nightfall of the day of the fire." Judson commissioned a new building, to be constructed of cobblestones, frame, and plaster over metal lath. The architects, Robert F. Train and Robert Edmund Williams, belonged to the Arroyo Guild and were directors of its architectural department. Still visible over the entrance to the Highland Park building–now home to The Judson Studios–is the crest of the Arroyo Guild: a rising sun, a hammer in an artisan's hand, and the proud words "We Can." Ceramic tiles and cast-stone ornamentation–the result of classroom projects–enliven the building facade.

In 1911 Judson married his second wife, Ruth Suffern, whom he had met at Masonic functions. Many years later he was granted a divorce. One of his complaints stated that his wife allowed a boarder to hold "liquor

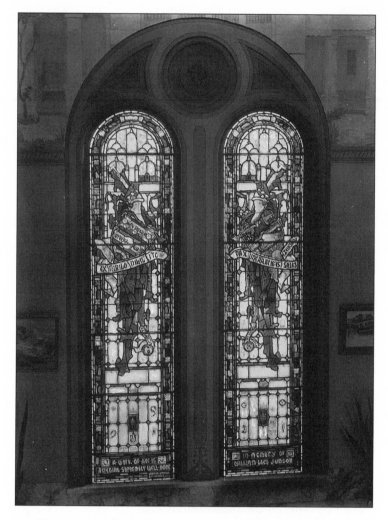

The memorial window commissioned by the family of
William Lees Judson. It was designed by Frederick Wilson,
noted for his artistry in stained glass.

parties," despite National Prohibition and Judson's own strong temperance sentiments.

The University of Southern California moved its fine arts classes back to the central campus in 1920. Judson retired as dean but continued to lecture and to paint until suffering a stroke in 1927. He died on October 26, 1928, at the age of eighty-six. As a memorial his family commissioned a stained glass window: "a tribute to the dean of early Southern California painters and to the golden future of art in California." Described as a jeweled biography, the window featured an inscription reflecting Judson's philosophy: "A work of art is anything supremely well done." The window was installed in the California State Exposition Building, which since has been demolished.

Many private collectors own work by William Lees Judson, and he is represented in several museum collections. Some of his early oil paintings are in the London Regional Art and Historical Museums in London, Ontario, where Judson once lived and taught. California museums with examples of Judson's work include the Southwest Museum and the Irvine Museum. (Two of the paintings in the Southwest Museum were done as illustrations for books by his friend George Wharton James.) A gallery at The Judson Studios often exhibits paintings by Judson, as well as his palette and brushes, framed like an evocative still life. Another reminder of the artist and his philosophy can be seen in the glaziers' room of the Studios. Art Nouveau lettering, painted on the walls by College of Fine Arts students, spells out three of Judson's dictums: "No steps backward; Art is only the beautiful way of doing things; Only the best is worthwhile."

(Facing page) Walter Horace Judson, first president of
the family's stained-glass business.

II
The Judson Studios

We are a cooperating group of artists, designers and craftspeople working in concert toward the finest end product for the client. All of us add our special talents while respecting the gifts of our co-workers. The cement of our studio is our mutual respect and pride in what we can accomplish for the future.
——Credo of The Judson Studios.

At the turn of the century most architects and contractors in Los Angeles ordered stained-glass pieces from catalogs put out by Eastern and Midwestern firms. William Lees Judson–practical as well as visionary–foresaw the important role that a good stained-glass workshop could play in the city. Young Walter Horace Judson, encouraged by his father, left St. Louis, where he was working with stained glass, and began a new career in Los Angeles. In 1897 he opened the Colonial

Business card used by the W. H. Judson Art
Glass Company around 1910.

Art Glass Company, forerunner of The Judson Studios. It was located in Mott Alley, a few blocks from the historic Plaza area of Los Angeles, once the center of city life.

In 1906 the business was reorganized under the name of the W. H. Judson Art Glass Company, which operated from a succession of addresses in downtown Los Angeles. Joining W. H. Judson as partners were his two youngest brothers, Lionel and Paul. In 1921 (without Paul, who had entered the construction business) the firm incorporated as The Judson Studios. A year earlier the firm moved into the Arroyo Seco building where William Lees Judson had presided as dean of the USC College of Fine Arts. The landmark building, at 200 South Avenue 66, is still home to The Judson Studios.

Walter Horace Judson, the first president of The Judson Studios, devoted nearly half a century to the art of stained glass, beginning as a thirteen-year-old apprentice in the famous McCausland Studios in Toronto and continuing as directing artist and manager for various stained-glass firms in the Eastern United States. He also studied for two years at the Cincinnati Art Academy. After settling in Los Angeles he worked for several years with Herman Raphael, a commercial glazier, and became head of the leaded-glass department. W. H. Judson found his true fulfillment as an artist after establishing his own studio. "His devotion to his craft was more than love," his son Horace recalled; "it was a deep, burning, fierce passion; an endless striving to realize fully the unlimited possibilities of glass."

A splendid example of W. H. Judson's early work is the great domed skylight crowning the rotunda of the

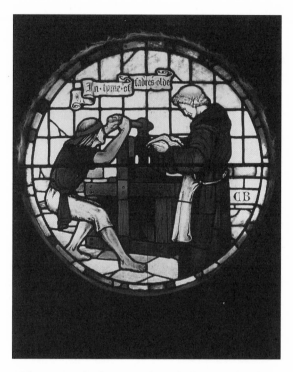

The stained-glass window fashioned by the
W. H. Judson Art Glass Company and
designed by printer Clyde Browne
for his Abbey San Encino.
Courtesy of Severin Browne.

Natural History Museum of Los Angeles County. Designed in 1913–for what then was called the Museum of History, Science and Art–the skylight features designs inspired by the English Arts and Crafts movement. Eighty years after its installation, the skylight was cleaned and repaired at The Judson Studios. W. H. Judson's grandson (Walter Worth Judson) and two great-grandsons (William and David Judson) worked on the restoration project, which was honored for excellence in craftsmanship by the Los Angeles Conservancy and the Stained Glass Association of America.

During the 1920s, as head of The Judson Studios, W. H. Judson supervised the translation into glass of designs drawn by Frank Lloyd Wright for two distinguished Hollywood homes: the Charles W. Ennis House and Aline Barnsdall's Hollyhock House. The Studios created leaded-glass windows for both residences, as well as an art-glass mosaic above the living room fireplace in the Ennis House.

A close neighbor of the Judson Studios is the Abbey San Encino, whose architecture combines elements of California mission and medieval castle. Clyde Browne, an author and fine printer, installed his press in the Abbey, which he built by hand between 1915 and 1929. For the print shop he designed a stained-glass rose window that portrays an Indian and a friar at a wooden printing press. The Judson Studios fabricated the window and received some free printing in exchange.

In 1927 the Studios completed an unusual assignment for architect Carleton Monroe Winslow, who had designed a series of ornamental windows for the Los Angeles Steamship Company's *City of Honolulu*. The

The San Diego Chapter
of
The American Institute of Architects

desiring to recognize merit in design and execution of work in Architecture and Fine Arts within its territory has caused the various classes of such work executed subsequent to the year Nineteen Hundred and Twenty to be judged by a competent Jury.

Glass Windows
in
Grace Lutheran Church

having been selected by this Jury as deserving of exceptional merit in its class, this Chapter does hereby award this

Certificate of Honor

to

Judson Studios
(Artist)

in appreciation of merit of this work

San Diego Chapter
The American Institute of Architects

PRESIDENT SECRETARY

Dated June 29, 1933

An early award recognizing the fine craftsmanship of The Judson Studios.

theme for the dining salon was "Romance of the Seas." One large panel depicted Odysseus and the Sirens, while other subjects included Jonah, John Paul Jones, Captain James Cook, and the pirate Henry Morgan. In addition to the stained-glass windows, Judson Studios created a large leaded-glass ceiling for the steamship's music room and an elaborate skylight with marine motifs for the upper rotunda. "No expense has been spared," the architect boasted, "to obtain the best in architectural inspiration and the highest degree of expert craftsmanship."

A commission received in 1928 kept the Studios busy for more than a year designing thirty-six windows for Hollywood First Methodist Episcopal Church. Just as the stained glass was being installed, the city's largest bank failed. Many prospective donors were no longer able to give to the church, and it was not until 1932 that The Judson Studios received its final payment: a little cash and a seaside lot donated by a parishioner. This Redondo Beach property (considered worthless at the time) was sold as soon as possible to help keep the Studios in operation. To a large extent what kept the Studios solvent during the Depression years was work commissioned by mausoleums and cemeteries. Among them were Forest Lawn Memorial Park in Glendale, and Rose Hills Memorial Park in Whittier.

In 1931 the Studios won extensive praise for seventeen stained-glass windows designed for the Garrett Memorial Chapel in Penn Yan, New York. Mortimer E. Freehof, the architect of the chapel, wrote to W. H. Judson that visitors were spellbound by the beauty of the windows. Paul Garrett, who commissioned them,

J. William Rundstrom adding black vitreous paint to a
medallion designed for the Pilgrim Faith Window of
the First Congregational Church, Los Angeles.
Photo by Daniel W. Brock.

declared himself overwhelmed by the color effects in glass and by the lifelike quality of the figures portrayed. W. H. Judson was responsible for the choice of colors; and Frederick Wilson–formerly Tiffany's master figure draftsman–was responsible for the design. "Ought we not to stress the fact, when blowing our own trumpet," Wilson suggested to Judson "that we have tried to keep in step, not only with Garrett but with Freehof AND it would be only decent to emphasise the fact that the whole is the result of TEAM WORK! NO ONE MAN IS THE WHOLE THING!"

Local chapters of the American Institute of Architects honored The Judson Studios with three awards in 1933: for stained-glass windows in the Bishop's School Chapel, La Jolla; in Grace Lutheran Church, San Diego; and in the First Congregational Church, Los Angeles. Frederick Wilson proudly likened the rose window in Grace Lutheran to some of the best glass work in France in the thirteenth and fourteenth centuries. In particular he mentioned the directness and simplicity of composition and the deep, rich coloring.

Creating stained-glass windows for St. James Episcopal Church, in Los Angeles, has been an ongoing project for The Judson Studios. Since 1932 it has designed, constructed, and installed every stained-glass window in the church: an anthology of changing styles during a period of more than half a century. Another long-term project, which also began in 1932 under the leadership of W. H. Judson, engaged the family and the Studios for the next twenty years. Over that period Judson Studios designed a series of commemorative windows for the First Congregational Church of Los

Horace T. Judson's bookplate. The scales of justice
refer to his law training, and the griffins to his
family crest. J. H. Buttrud, who drew the
bookplate, was for many years the
chief designer at The Judson Studios.

Angeles, which has acclaimed the work as "a benedic-
tion of light." Among the last installations was the
majestic north transept window—one of the largest
church windows in the country. It took two years to
complete and incorporated some 27,900 pieces of
"antique" (hand-blown) glass. Most of the windows in
the First Congregational Church take their inspiration
from the Bible, but five majestic windows pay tribute to
leading figures in science, medicine, government, and
the church. Among those depicted are Leonardo da
Vinci, Johannes Gutenberg, Junipero Serra, Benjamin
Franklin, and Mahatma Gandhi. Also portrayed is the
craftsman and monk Theophilus, whose twelfth-century
treatise on the arts gives practical advice on creating a
stained-glass window.

W. H. Judson believed there was no finer art than
stained glass, and he devoted himself to the craft from
his apprenticeship as a teenager until his death in 1934.
Critics praised his creative designs and keen perception
of color and form. "He was probably the first artist on
the Pacific Coast to realize and utilize the beauty of
antique glass," his son Horace wrote, "and his struggle
to wean the public away from the sloppy sentimental-
ism of pictorial opalescents was a long and bitter one."
The older Judson was proudest of the Sermon on the
Mount window that he designed for the University of
Redlands chapel. Architect Herbert J. Powell told him,
"I think it is the best piece of stained glass I have seen in
Southern California."

Horace Judson, who succeeded his father as presi-
dent of The Judson Studios, served an early apprentice-
ship at the Studios, and while still in high school he

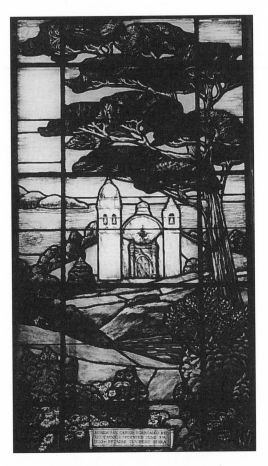

A depiction in stained glass of
Mission San Carlos Borromeo.
The window is one of a series in
Inglewood Park Mausoleum.

began a superb collection of books on stained glass. At the suggestion of his father, who thought the experience would be useful to the business, Horace earned a law degree as well as a bachelor's degree from the University of Southern California. Admitted to the bar in 1930, he specialized in probate and corporate reorganization, and he prepared the National Recovery Act code for the stained-glass industry of California. After his father's death, he retired from active law practice and devoted himself to management of The Judson Studios—initially in partnership with his uncle, Lionel Judson, who had been in charge of shop production, shipping, and installation of windows since its earliest days.

"Romance of the Mission Days in Glowing Color at New Mausoleum," read a local headline in 1940. The reference was to five large windows designed by muralist and decorator Lucile Lloyd and created at The Judson Studios for the Inglewood Park Mausoleum. The two windows on either side of the entrance depict Gaspar de Portolá, military leader of the Sacred Expedition to Alta California, and Father Junípero Serra, the spiritual leader. Windows at the far end of the entrance hall portray the Franciscan missions founded at San Diego, Carmel, and San Francisco. Commenting on the windows, an Inglewood newspaper observed: "They are well worth a visit both by those who know their California history and by those who ought to know it better."

During World War II, when there was a shortage of manpower and materials for non-essential industries, The Judson Studios limped along with a few men past

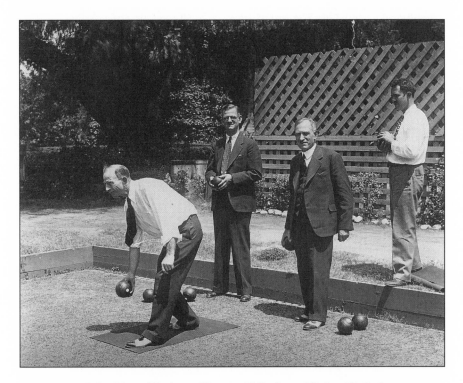

John Lionel Judson, Horace T. Judson, Walter H. Judson,
and J. William Rundstrom on the bowling green
outside The Judson Studios.

retirement age and with whatever materials were in stock as of the Spring of 1942. Horace Judson took leave from the Studios to enroll in a special program at the California Institute of Technology. Upon completion of the course he went to work as a standards engineer at the Lockheed Aircraft Corporation. Lionel kept the Studios in operation, making do with the limited supplies of lead, glass, tin, and copper on hand.

When Lionel resigned in 1945, two of his nephews joined Horace as partners. They were Richard Wiley, who gave up his partnership a year later, and J. William Rundstrom, who played an active role in the Studios until his retirement in 1960. Rundstrom's mother, Bertha Judson Rundstrom, was one of William Lees Judson's three daughters. As a young woman she joined the Ruskin Art Club of Los Angeles, taught art history at the College of Fine Arts, and worked for the Studios, designing landscape windows and Tiffany-style lamps. The Rundstroms lived just a few steps from The Judson Studios; and beginning as a fourteen-year-old, J. William worked there during school vacations, learning to waterproof a leaded window, make packing boxes, and pack the windows for safe shipping. After a six-year apprenticeship in all phases of stained-glass art, he became head of the painting department. He also served on the executive board of the Stained Glass Association of America.

Horace Judson, who was president and business manager of The Judson Studios, especially enjoyed working with clients to select the appropriate iconography and design; and–like his father–he was the studio colorist. He had a scholarly knowledge of church archi-

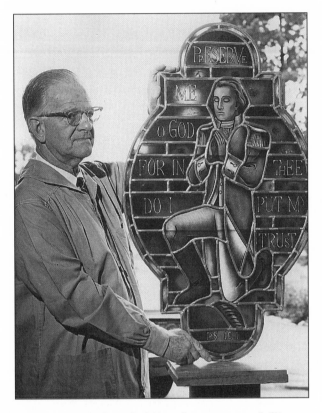

Horace T. Judson holding the center medallion
of the Prayer Window designed for the
Faith of Our Fathers Chapel at
Valley Forge, Pennsylvania.
Photo by Joe Friezer.

tecture, symbolism, and window design, and he expect-
ed the craftsmen he hired to be knowledgeable in
church history, general history, and art. Of the nearly
one thousand projects on which he worked, the ones in
which he took most pride were the Capitol Prayer
Room in Washington, D.C., the upper level of the Air
Force Academy Chapel in Colorado Springs, Saint
Paul's Episcopal Church in San Diego, and the First
Congregational Church in Los Angeles.

"We try to catch something of the spirit and sincerity
of the ancient craftsmen who builded similar windows in
medieval times," Judson said in a discussion of the First
Congregational Church windows. On another occasion
he remarked, "The only difference between our work and
that of the 12th and 13th century European cathedrals is
that theirs have had the time to age to a mellowness of
coloring which we can't obtain without aging. Ours, in
time, will acquire that mellowness."

The Capitol Prayer Room, which opened in 1955, was
designed as a place in which members of the House and
Senate could pray or meditate without distraction. A
small, secluded room near the Rotunda, it is simply fur-
nished with an oak altar, two kneeling benches, and ten
armchairs. Above the altar is a stained-glass window,
designed and executed by The Judson Studios, and
donated by the Studios and all of its artisans. The win-
dow depicts the Great Seal of the United States and the
kneeling figure of George Washington. A representation
of Washington at prayer appears also on a stained-glass
window created by The Judson Studios for the Faith of
Our Fathers Chapel, Freedoms Foundation, at Valley
Forge, Pennsylvania.

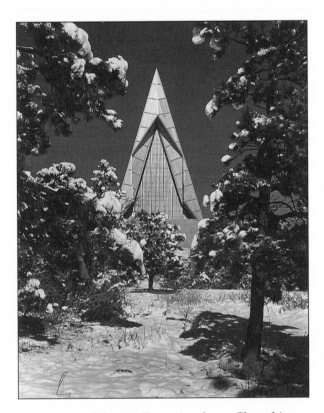

A view of the Air Force Academy Chapel in Colorado Springs. Craftsmen of The Judson Studios worked for three years fabricating sixty-four stained glass panels for the upper level of the chapel. *Photo by Stewarts.*

Dominating the campus of the Air Force Academy in Colorado Springs is the Air Force Academy Chapel, a two-level house of worship with four separate religious meeting rooms. Skidmore, Owings & Merrill designed the building, which was completed in 1962. The soaring rooftop design, with seventeen tetrahedral-shaped spires, suggests the mountain landscape, as well as the concept of flight. Between the spires are sixty-four stained-glass window panels that fill the upper level of the chapel with a warm, glowing light.

It took three years to complete the huge windows. Craftsmen from The Judson Studios carried out the monumental project in a workshop they established next to the chapel. To fabricate the window panels they used 24,384 dalles: individual pieces of specially molded slab glass in 24 colors and 32 shapes. Craftsmen chipped approximately 35 percent of the surfaces of the glass dalles to introduce jewel-like facets.

Another commission in which Horace Judson took special pride was designing stained-glass windows for St. Paul's Episcopal Church (now the Episcopal Cathedral) in San Diego. "The planning and creation of these windows has been a deep and thrilling experience," he told the rector in 1952. "Being somewhat of a fanatical Episcopalian, I have caught all the symbolism and mystical meaning with which our faith is so richly endowed."

The Judson Studios undertook a number of diverse projects in the 1960s, including work for a private school chapel, a motion picture studio, and the United States Air Force. The chapel was Saint Saviour's, which is located on the upper-school campus of Harvard-

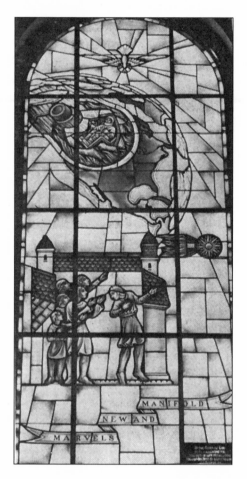

One of twelve stained-glass windows created
by The Judson Studios for Saint Saviour's
Chapel in Studio City, California. Illustrating
the theme "Marvels new and manifold," an
orbiting astronaut symbolizes the modern,
while the Halley's Comet vignette from the
Bayeaux Tapestry symbolizes the ancient.

Westlake, in Studio City, California. Saint Saviour's Chapel is a landmark building designed by noted architect Reginald Johnson in 1914. To commemorate the fiftieth anniversary of the chapel, Harvard School (now Harvard-Westlake) had The Judson Studios fabricate twelve stained-glass windows based on designs by the school chaplain. Each window illustrates a line from the school hymn, "For the brave of every race." On the twelfth window are the concluding words of the hymn: "Heirs of their great heritage, in their footsteps will we tread."

Nineteen artists entered the contest to design a Test Pilot Memorial Window for Edwards Air Force Base in Southern California. The winning design was submitted by Peter Farrell, of The Judson Studios. Employing rich symbolism, he illustrated the themes of "To the Unexplored" and "To the Stars through Faith." The window was dedicated in 1966, a year in which artisans at The Judson Studios were working also on stained-glass windows for the Point Mugu Naval Chapel and the Camp Pendleton Marine Corps Base Chapel.

In a lighthearted postscript to its work in the sixties, The Judson Studios installed a stained-glass window in a regulation phone booth, one of the props used in the motion picture *Funny Girl*, the story of actress Fannie Brice. The Studios also made stained-glass windows for a set re-creating the saloon owned by Miss Brice's father.

In addition to its stained-glass creations for *Funny Girl* and a number of other films, The Judson Studios has designed windows for several Hollywood stars, including Jackie Cooper, James Garner, and Robert

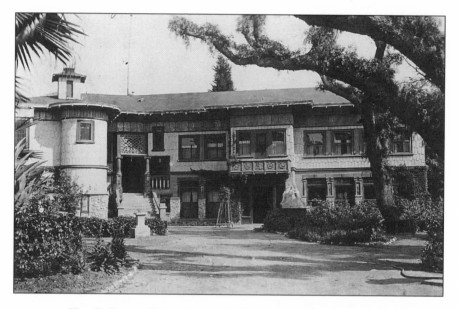

The College of Fine Arts, rebuilt in 1910 after a disastrous fire.
The Judson Studios has occupied the building since 1920.
Courtesy of Virginia Neely.

Vaughan. One early client was John Barrymore, who concluded an all-night party by showing up at The Judson Studios at 8 A.M. ("drunk as a lord") to check on the progress of a window for his Sunset Strip home. The actor was delighted with what had been done, and even more delighted when the finished window was installed. In a bibulous gesture of appreciation, he insisted on bestowing bottles of whiskey on W. H. Judson and his son Horace. William Lees Judson–a Methodist teetotaler–would have been scandalized.

After nearly half a century in its landmark building on the Arroyo, The Judson Studios was shocked to learn in 1969 that city inspectors considered it "a stained-glass factory," an enterprise that did not belong in the apartment house neighborhood that had grown up around it. Demolition of the building was averted when the Los Angeles Cultural Heritage Commission, by unanimous vote, declared The Judson Studios Historic-Cultural Monument #62: "the preeminent center in the West for the development of master craftsmen in the historical art of stained glass and mosaics."

During the 1970s Horace Judson gradually retired from his work at the Studios, but he never lost his love of stained glass. He continued to lecture on the subject, and in 1973 he helped establish a stained-glass program at the College of the Ozarks, in Point Lookout, Missouri. His involvement came about when a Missouri bank repossessed an art-glass company and turned its collection of glass over to the school. Eager to preserve the art of stained glass and to add a project to its student work program, the school turned to Judson for help. He arranged for the college art instructor to visit The

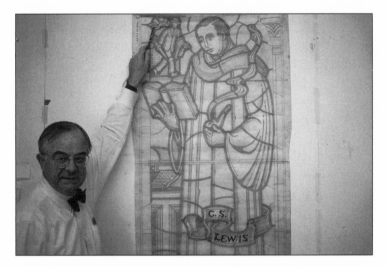

Walter W. Judson standing by the cartoon for a stained-glass
window installed in Saint Luke's Episcopal Church,
Monrovia, California. The eight-foot-tall window
shows C. S. Lewis, author of *The Chronicles of
Narnia* and *The Screwtape Letters*.

Judson Studios, then went to Missouri himself to set up the program and to teach for a semester.

Horace Judson quite literally left his mark on the Studios. Near the front entrance is a patio made with little bricks that he formed and fired himself. His thumbprint is visible in each one. As befits a patio at The Judson Studios, small squares of stained glass are set among the bricks in a colorful mosaic.

Walter W. Judson, who succeeded his father as president in 1968, had once considered a career in law or the foreign service. He observed, however, that few of the attorneys he knew seemed content. "Then I looked around the glass studio. It seemed as though the workers were more at peace with themselves than most other people." After graduating from the University of Southern California, where he majored in English and minored in history and political science, he joined the family business. He especially enjoys making abstract concepts visual. "If you had to put a word to me so far as my profession," he told Richard Hoover, editor of the journal *Stained Glass*, "I'd probably say I'm a professional iconographer." Judson has taught university courses in stained-glass craftsmanship and written a textbook, *Stained Glass: A Step-by-Step Guide*, which is dedicated "to those who are willing to create with their hands their most beautiful thoughts with living light." From 1988 to 1990 he served as president of the Stained Glass Association of America (SGAA), and for a number of years he has been the apprenticeship chairman of the organization. The *SGAA Reference and Technical Manual* includes several chapters based on his own textbook, and also features material that he wrote especially for the manual.

Douglas Judson, Walter's older brother, has found fulfillment in two professions: as an artisan in The Judson Studios and as an Episcopal priest. He credits the inspirational messages of stained glass with helping influence his decision, at the age of thirty, to study for the priesthood. Now a non-stipendiary associated with Saint Andrew's Episcopal Church in Torrance, he works at the Studios four days a week. His specialty–as it was before entering the priesthood–is fashioning windows of faceted glass.

During the decade of the seventies, The Judson Studios responded to an increasing demand for stained-glass installations in commercial buildings. For the Stanford Court Hotel, on Nob Hill in San Francisco, the Studios fashioned a vaulted, stained-glass canopy over the entrance court and another stained-glass dome over the lobby. So dramatic was their appearance that a number of other establishments promptly commissioned similar work. In the space of ten years, The Judson Studios fabricated large domes and vaulted ceilings for banks, casinos, a shopping mall, and a convention center. Two of the most spectacular installations were in Las Vegas. A barrel vault in Caesar's Palace covers the dance floor and can be slid away on pleasant evenings. Spanning the gaming room of the Tropicana Casino is the largest stained-glass barrel vault in the country: 28 feet wide and 107 feet long.

Stained glass from The Judson Studios appears also in office buildings, restaurants, clubhouses, shops, libraries, schools, and residences. Throughout its history, however, most of its work has been for houses of worship. Some recent windows commemorate what one

writer has described as "twentieth-century saints." St. Mark's Episcopal Church in Altadena (where Horace Judson once served as lay reader) has a large collection of windows showing great contemporary leaders, including Pope John XXIII, Albert Schweitzer, Mother Theresa, and Archbishop Desmond Tutu. St. Luke's Episcopal Church, Monrovia, California, commissioned a window honoring British author, scholar, and theologian C. S. Lewis. He is portrayed in academic robes, reading a book, and smoking a pipe. (It was the first time that The Judson Studios had ever used stained glass to depict a smoker.) Classics by Lewis inspired details in the window. Pictures of a young girl, a lion, and a lamppost refer to *The Chronicles of Narnia*; and the figure of an Englishman with a young devil on his shoulder recalls *The Screwtape Letters*. "This is the last stained-glass window to be placed at St. Luke's," Walter Judson observed. "My grandfather put the first one in back in 1924."

Photographs of work by The Judson Studios have twice appeared on the cover of *Stained Glass*, the quarterly publication of the Stained Glass Association of America. The Summer 1989 issue shows the *Arbor of Light* designed for the Mountain View Mausoleum in Altadena, California, by Dr. Jae Carmichael: a painter, sculptor, and film producer who always has been fascinated by light and color. The artist worked closely with artisans at The Judson Studios in creating her *Arbor of Light*: a twelve-foot stained-glass window and a sixty-foot stained-glass ceiling. The images depicted–leaves, buds, and full-blown flowers–suggest life, growth, and regeneration. Even the faintest light shining through the

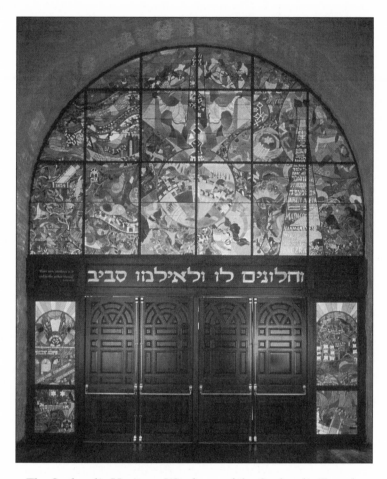

The Sephardic Heritage Windows of the Sephardic Temple
Tifereth Israel, on Wilshire Boulevard in Los Angeles. The
windows were designed by Israeli artist Raphael Abecassis
and translated into stained glass by The Judson Studios.
Courtesy of Bittan Fine Arts.

stained glass reflects the bold shapes and glowing colors on the marble floor and walls of the corridor: a corridor of radiance. "Seldom has the proven 'fine' artist shown the ability to truly understand the medium of the stained-glass craft as thoroughly as Jae Carmichael has shown in this mausoleum corridor," Walter Judson observed. "The flow and blending of color is fluid and exciting, and yet the crispness of glass and lead line is not lost. . . . We believe that the stained glass in this one corridor has begun a new style, a change in the direction of future design."

The summer 1994 issue of *Stained Glass* features the Sephardic Heritage Windows in the Sephardic Temple Tifereth Israel, on Wilshire Boulevard in Los Angeles. Raphael Abecassis, a Sephardi-Israeli artist, designed the windows, which depict the odyssey of Sephardim from the Iberian Peninsula to Los Angeles, the establishment of the first Sephardic synagogue in the city, and the inauguration of Temple Tifereth Israel. The intricate, richly colored composition incorporates Jewish symbols and Sephardic motifs. Design elements include the twenty-two letters of the Hebrew alphabet, the seven-branched Menorah, and the ram's horn blown on Rosh Hashanah. Also depicted, on a ladder of spirituality, are the names of revered Sephardi scholars, such as the great rabbi and philosopher Maimonides. At the center of the design is the City of Jerusalem, set in a pomegranate, a fruit from the Holy Land.

The Judson Studios, which fabricated and installed the windows, had to translate into stained glass the artist's five watercolor sketches, which indicated no mullions or lead lines. The artisans worked with care to

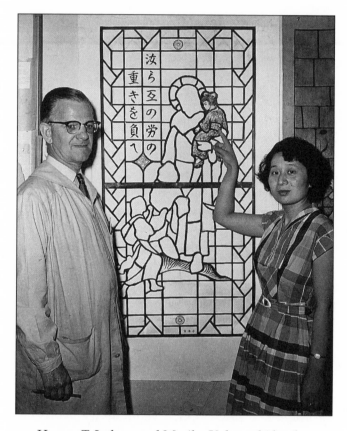

Horace T. Judson and Mariko Kobayashi by the
full-size working drawing, or cartoon, for the
stained-glass window designed at The Judson
Studios and donated to St. Timothy's
Episcopal Church in Osaka.
Photo by Daniel W. Brock.

respect the free-flowing nature of the design and its complex symbolism. The Studios made a painstaking selection of glass to reproduce the effects shown by the artist in his original watercolor sketches. When the Abecassis Sephardic Heritage Windows were dedicted in 1994, one art consultant acclaimed them as "a magnificent work of art in stained glass, an historically meaningful and technically challenging masterpiece."

Since 1985 The Judson Studios has been fabricating windows for Mary, Queen of the Universe Shrine in Orlando, Florida. A major Catholic complex, it serves the large tourist population visiting Walt Disney World and other central Florida attractions. The main church has a 2,000-seat nave below an 85-foot vaulted ceiling. When completely installed, there will be sixteen clerestory windows and fourteen Magnificat Windows, all of them the work of The Judson Studios.

"This is a major project, which will be seen by peoples of all nations and religions," Walter Judson wrote to the architects. "It should draw the curious and uplift the believer." Describing the credo of the Studios he said, "We work as a team to begin with, and I operate as a representative of the team. Our philosophy is that each contributes one's best on a team project, and yet each project is led by one artist for continuity. A project as large as Queen of the Universe needs a constant infusion of excitement and newness which only a team effort can create."

Stained-glass windows from The Judson Studios can be seen throughout the United States, as well as in Norway, Korea, Viet Nam, and Japan. Two examples, done forty years apart, can be seen in Osaka. In 1955, for

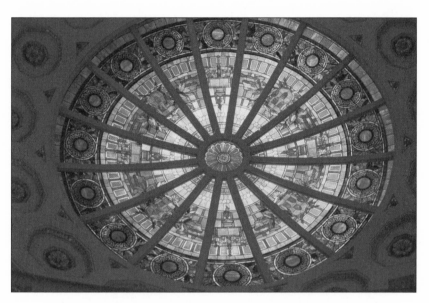

The skylight dome in the Natural History Museum of Los Angeles County. It was designed in 1913 by Walter Horace Judson. His grandson and two great-grandsons worked on restoration of the dome in 1995.

St. Timothy's Episcopal Church in Osaka, The Judson Studios created a window showing Jesus with three children–one of whom is wearing a richly colored kimono. The Studios contributed the window after learning that Osaka members of the Girls Friendly Society wanted to beautify their church. The craftsmen worked on the window in their spare time as their gift to the Girls' Friendly Society. At the unveiling of the window, the girls filed into church singing "In Christ there is no East or West."

The most recent Osaka project, completed in 1995, is a series of eighteen windows designed around the central theme of Ideal Love. They appear in the wedding chapel of the Imperial Hotel. Done in the nineteenth-century style of William Morris and Edward Burne-Jones, the windows portray King Arthur, Queen Guinevere, and the twelve knights of the Round Table.

Another project completed in 1995 spans seventy-two years of Los Angeles history and four generations of the Judson family. William (Bill) Judson served as project artist for the Memorial Branch Library in Los Angeles–a building whose first window was designed by his great-grandfather, Walter Horace Judson. The branch library was erected in 1930, across the street from the old Los Angeles High School. Students and alumni of the school purchased the library site in 1923 to commemorate the twenty high school alumni who died in World War I.

Windows in the Parliament Building in London inspired the stained-glass window that W. H. Judson designed in 1930 for the library reading room. An inscription expresses the hope for peace among nations. The new windows echo the English Tudor style of the

original window but with a more contemporary palette. They express the theme "Peace through Knowledge." A medallion on each window symbolizes one section of the Dewey Decimal cataloging system, such as reference, language, literature, science, and the arts. A picture of the old Los Angeles High School appears on the medallion for history.

Another library featuring work from The Judson Studios is the South Pasadena Public Library, which recently celebrated its centennial. The design in its stained-glass skylight suggests the orange trees that once grew throughout the city.

COLOR PORTFOLIO

Memorial window in Church of Our Saviour, San Gabriel,
California. Donated by Horace Judson in memory of his
father, Walter Horace Judson, master craftsman.

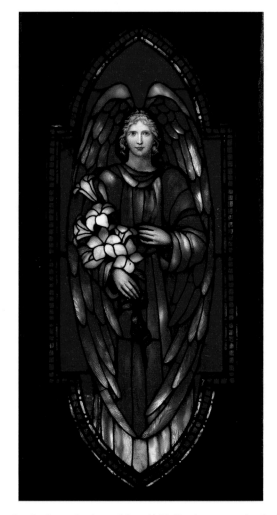

Angel window designed by A. E. Brain, an artist in The
Judson Studios in the early twentieth century. The window
is displayed in the library of the Studios.

Window in floral pattern designed for the
California PEO Home, Alhambra, California.

Craftsman-Gothic window in Saint Paul's
Episcopal Church, Burlingame, California.

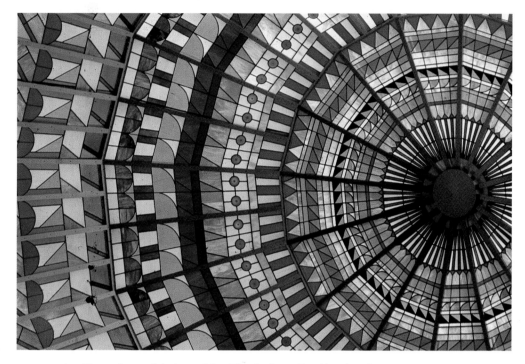

Art Deco dome fabricated by The Judson Studios for the
Jewel Court of South Coast Plaza, Costa Mesa, California.

Radiance Corridor designed by Jae Carmichael and fabricated at The Judson Studios for Mountain View Mausoleum in Altadena, California.

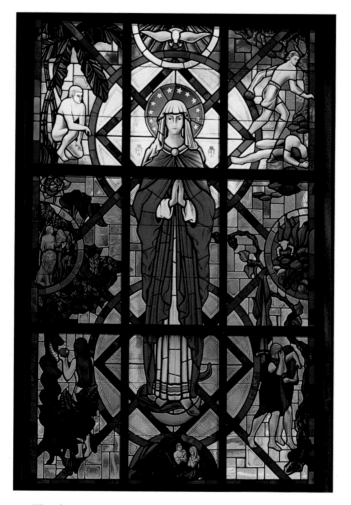

The first in a series of Magnificat Windows being
designed for Mary, Queen of the Universe Shrine in
Orlando, Florida.

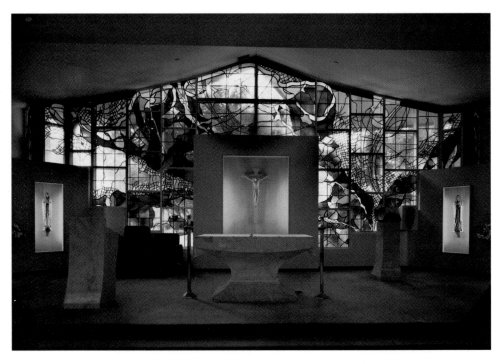

Leaded-glass windows in Saint Jude's Hospital, Fullerton,
California. *Photo by Duane C. Alan.*

(Facing page) Artist Arthur Y. Park with the window he
designed for Sungnam Presbyterian Church in Seoul.

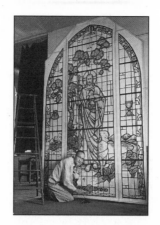

III
The Art of Stained Glass

Only glass combines with light to employ the brilliance of the
sun, the nuances of the cloud, and the palette of the sky itself.
———*Adalié Brant, 1983*

"On the banks of the Arroyo Seco, between Los
Angeles and Pasadena," begins an article on stained
glass, "The Judson Studios is engaged in the medieval
art of designing and fabricating windows of living
light." The adjective is well chosen, for stained glass
does not come to life until animated by transmitted
light. "We have to mix it with our colours," wrote artist
Veronica Whall; "we have to harness it; to tie it down; to
make it stop where we want it,–or let it pour through; a
stupendous, living, ever-changing force."

Light, line, and color: these are the essential elements
of a stained-glass window. Leaded lines define the areas

61

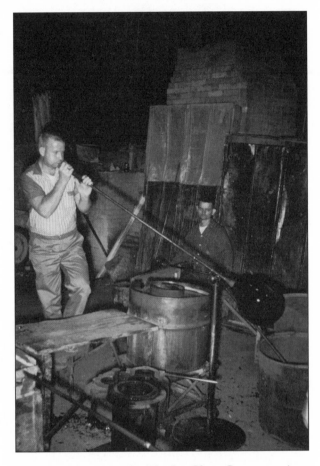

A glassblower at the Blenko Glass Company, in
Milton, West Virginia, which supplies some of the
glass used by The Judson Studios.

of color and design, light awakens the colors, and the colors themselves are in the glass, not painted on. They result from adding metals and metallic oxides to a pot of molten glass. Thus, gold is added for ruby glass, cobalt for deep blue, manganese for amethyst, and so on. "By stained glass," Horace Judson once said, "I mean a window composed of a limitless number of jewel-like bits of glass colored in the making. The colors of a true stained-glass window follow definitely the coloring of precious jewels, and the names denoting these colors are taken from the names of jewels, such as ruby, emerald, and sapphire. . . . A window composed of these pot-metal colors will never fade or change; but will always be charged with color and vital life, reflecting the moods of changing light. Sometimes it will glow with bright and lively color, and at other times be solemn with deep, rich mystical color."

The Judson Studios does not make its own glass; even in ancient times, the glassmaker rarely was the same person as the stained-glass artist. Companies in West Virginia and Indiana, as well as companies in England, France, Italy, and Germany, supply most of the glass used by the Studios. Hand-blown glass (known also as antique or pot-metal glass) is especially prized and is admired for its natural imperfections. Machine-rolled cathedral glass may also be used. The sheets of glass are stored upright in wooden bins. Rare antique glass from England is kept apart in a room laughingly referred to as "Fort Knox." In stock at The Judson Studios is glass in more than a thousand colors. "Every time we receive a new shipment of glass, it's like Christmas around here," Walter Judson told a reporter.

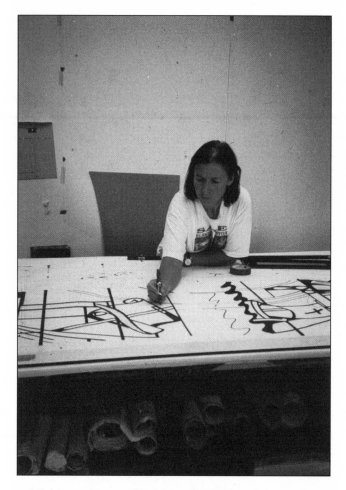

Making a layout. The artist is Barbara Gawronski,
who also did the full-size cartoon.

Although windows from The Judson Studios appear in buildings as disparate as libraries and casinos, most of its commissions are for houses of worship. Study and research are essential, Horace Judson observed, to understand and translate into stained glass something of the literature, beliefs, and symbolism of the religion or denomination for which a window is designed. Walter Judson, the present owner of The Judson Studios, takes pride in his knowledge of iconography, as did his father before him.

Today, as in medieval times, creating a stained-glass window is an art done completely by hand. Whatever the nature of the project, it first comes to life as a small watercolor sketch (often a work of art in itself). This preliminary design, usually on a scale of one inch to the foot, vividly suggests how the full-size window will appear. Once a design has been approved, the artist makes a detailed working drawing, or *cartoon*, the exact size and shape of the window opening to be filled. For use in the various processes, three carbon copies of the cartoon are made by tracing the centers of its heavy dark lead lines. The master copy, on which each segment of the design is numbered and color-coded, will serve as a reference for final assembly of the window. The second copy (known as the *cutline drawing*) will guide the artisan who puts the glass segments into position and binds them with the lead strips. The third copy (the *pattern drawing*) will be cut along the heavy leadlines to create templates for each piece of stained glass to be used in the window. The templates are cut out with special three-bladed shears. They leave a margin around each piece of the pattern to allow for the heart of

the lead channels into which the pieces of stained glass will be fitted.

Next the stained glass is selected, always bearing in mind the light intensity and atmospheric conditions where the window is to be installed. The glass is cut to pattern with a steel-wheel cutter (a great improvement on the red-hot iron used by a medieval craftsman). The templates then are arranged in order on the cutline drawing, which has been placed on a light table corrected to be nearly equal to sunlight. Each stained-glass segment is positioned on the corresponding template so the colors can be approved.

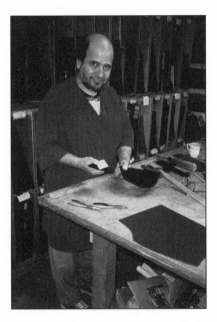

Abdelkrim Kebir cutting stained glass
to the shape of the pattern.

The next steps are *tracing* and *painting* on each piece of glass. The artist adds the lines of definition by placing the glass on the cartoon and tracing its details onto the glass. The artist also gently brushes or stipples the glass with a half-tone of paint (a process known as *matting*) to give the effect of shading. The "paint," whose color ranges from reddish-brown to black, actually is powdered glass mixed with red oxide of iron and gum, with water added as necessary. After the tracing, painting, and matting, the glass pieces are fired at least twice, at 1250°, to fuse the glass and vitreous paint.

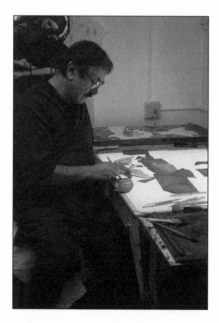

Arpad Maghera painting details with vitreous paint that will fuse with the glass when placed in the kiln.

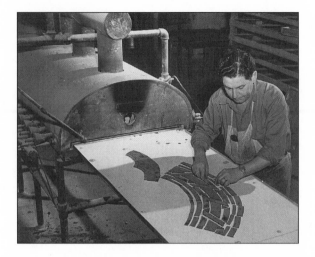

Pete DiLorenzo with stained-glass pieces ready for the kiln.

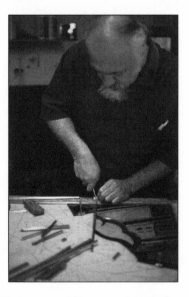

Paul Martinez assembling a stained-glass window,
fitting each piece into a grooved lead strip.

The pieces then are assembled, one section at a time. Using the cutline drawing as a guide, the lead glazier fits each piece of glass into a grooved H-shaped lead strip called a *came*. During this process, nails lightly hammered in along the outer edge of the section hold the lead strip and glass in place. (Horseshoe nails are used for this purpose at The Judson Studios because they are easy to insert and remove.) When each piece of glass has been fitted into the grooved strip, the joints are soldered on both sides, and the window is water-proofed (again on both sides) by forcing "cement" (actually a mastic) between the glass and the leads. (The process is known as *cementing* because Portland cement once was an ingredient in the mixture.) Any sections of

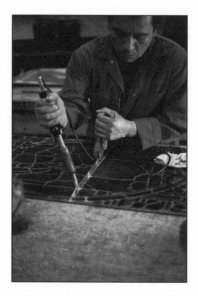

Jorge Vidal reinforcing a stained-glass
window with horizontal saddle bars.

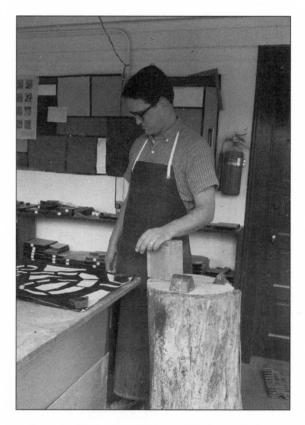

Douglas Judson working with faceted glass.

the window larger than about two square feet are reinforced with horizontal saddle bars. These are attached mechanically with solder to stiffen the panel and keep it from buckling or deflecting. The window will be ready for installation after it has been examined and approved by each craftsman who worked on it.

Windows of faceted glass have become popular in recent years. For these windows, the molten glass is neither hand blown nor machine rolled, but is poured into square or rectangular molds. These produce slabs of colored glass, one to three inches thick. These are known as *dalles*, from the French phrase *dalles de verre*: paving stones of glass. As with any stained-glass window, the artist makes a preliminary sketch, a full-size cartoon, and a careful selection of colors. A sharp double-edged hammer is used to cut the dalles to the shape of the pattern and to chip–or facet–the surface of the glass. The cartoon is coated with wax (so it can later be removed), the glass pieces are laid out (faceted side up), and everything is enclosed in a wooden form the exact size of the window opening. Sand is sprinkled between the dalles, and a matrix of epoxy poured around them. Before the epoxy completely hardens, sand is sprinkled on its surface to keep the epoxy from having a shiny appearance. Good faceted design is strong and broad, with the glass suggesting but not defining the details. The negative space surrounding the glass is all-important to the design.

Early examples of faceted stained glass can be seen today in the ancient mosques of Turkey and North Africa. The Judson Studios has worked on a number of buildings that incorporate faceted stained glass. These

include the soaring panels of the Air Force Academy Chapel in Colorado Springs (completed in 1962) and the windows of the Church of the Beatitudes in Phoenix. The sanctuary of the Phoenix church has six aisle windows and a great chancel window which were designed and built by the Judson Studios in 1972. The chancel window, which is fifteen feet wide and fifty-five feet high, is composed of dalles in fifty-five colors, cast in bronze epoxy, and finished with Monterey sand. In 1980 The Judson Studios created thirty-two windows of faceted stained glass for the church's new assembly hall. The windows portray great teachers, from St. Paul to Reinhold Niebuhr, and include in this august company the anonymous church school teacher.

The steps followed in making a stained-glass window have remained essentially unchanged since they were first described in the twelfth-century treatise *On Divers Arts*, by Theophilus. Subject matter and symbolism quite often are the same as in medieval windows, since most stained glass is found in a religious setting. The luminous words of Abbé Suger apply as truly to the contemporary house of worship as to the twelfth-century Abbey Saint-Denis, of which he said: "The whole church would glow with the wonderful, continuous light of the very holy windows, illuminating the beauty of the interior."

The twelfth and thirteenth centuries are considered the Golden Age of stained glass. Pictorial windows in the soaring Gothic cathedrals combined narrative power with a glorious luminescence. In the memorable phrase of Otto von Simson, the church interior became a translucent cosmos. "The Gothic wall seems to be

porous," he said; "light filters through it, permeating it, merging with it, transfiguring it."

The Abbey Saint-Denis, which has been called the first Gothic structure, made the first extensive use of narrative medallion windows. Such windows present their stories within a series of highly ornamental and brilliantly colored medallions in geometric shapes: circles, squares, lozenges, and quatrefoils. The same craftsmen who worked on the Abbey may also have worked on the Cathedral of Chartres, whose 176 windows are radiant masterpieces of twelfth- and thirteenth-century stained glass. Equally beautiful and impressive are the thirteenth-century windows in Canterbury Cathedral, the first Gothic edifice in England.

The windows of Chartres and Canterbury, like those of the Abbey Saint-Denis, have splendid pictorial medallions. Another treasury of medallion windows can be seen at Sainte-Chapelle, built in the thirteenth century in Paris. More than a thousand scenes are portrayed in medallions on the fifteen windows that form a stained-glass wall on three sides of the chapel. Some thirteenth-century windows largely abandoned the jeweled colors of stained glass for large areas of white glass, often painted with naturalistic plant motifs. There were practical reasons for these grisaille windows: white glass was cheaper than colored and it admitted more light into the building.

Glass in a new palette of secondary colors was available to stained-glass artists in the fourteenth century. Artists benefitted, also, from the discovery that painting glass with silver salts produced various shades of yellow. Another new technique involved working with a kind of

laminated glass (known as "flashed" glass), which was produced when clear glass, while still pliable, was dipped into molten colored glass. The stained-glass artist achieved detailed effects by cutting through the upper lamina of color to expose the underlying layer.

Glass artists of the fourteenth century, influenced by Flemish and Italian paintings, displayed a new interest in perspective and the three-dimensional. In addition, the artists treated the human figure with more sense of the individual. Portraits of donors became popular, and heraldic shields helped identify the persons portrayed. An ornamental canopy above the figure–a convention since the twelfth century–became more elaborate. Motifs from nature were depicted with increasing realism, as though observed at first hand.

During the Golden Age of stained glass, artists designed mosaic-style windows composed of many small, irregular pieces of colored glass. Leading was an essential, and integral, part of the design. By the sixteenth century, however, artisans were disregarding the role of leadwork in the overall design. Lead became simply a means of holding the artwork together. Emphasis shifted to painting the glass, using vitreous enamel. As William Warrington observed: "Great artists in engraving and oil painting had now arisen, whom the practicioners on glass, misunderstanding its capabilities, vainly strove to rival. Now as the latter art depends for its beauties and effects on the association with appropriate architecture and upon principles opposite to those of oil and shadowy painting, it follows that the attempt to treat glass like canvas must prove a comparative failure."

Not until the Gothic Revival of the nineteenth century did stained glass again become an important art form. Dante Gabriel Rossetti, William Morris, and Edward Burne-Jones were among the noted English artists commissioned to design windows. They had superb glass to work with, thanks in part to the efforts of one man. He was Charles Winston: barrister, amateur archaeologist, and authority on ancient stained glass, who analyzed fragments of medieval glass to discover their composition. His experiments led to the production of pot-metal glass that rivaled ancient glass in color and texture.

In 1861 Morris founded a decorative arts firm that quickly established a reputation for beautiful handcrafted items–not only stained glass, but also wallpapers, weavings, embroideries, chintzes, carpets, and furniture. The firm intended to make these things available, said an early prospectus, "at the smallest possible expense." As Morris explained in one of his lectures, "I do not want art for a few, any more than education for a few, or freedom for a few."

Just a year after its founding, the firm won a medal for the color and design of its stained-glass windows "in the style of the Middle Ages." Some competitors found it difficult to believe that any modern craftsman could have produced such windows. They charged (quite wrongly) that Morris must have taken old glass, restored and remounted it, and passed it off as new.

Four of Morris's friends (Rossetti, Burne-Jones, Ford Madox Brown, and Philip Webb) worked with him in creating the firm's stained-glass windows. Burne-Jones supplied the greatest number of designs; while Morris

selected the glass to be used, chose the colors, did some of the background patterning, and worked out the leading, which–as in earlier centuries–was an integral part of the design. Important windows by Burne-Jones and Morris can be seen in Birmingham Cathedral, Salisbury Cathedral, and Oxford's Christ Church Cathedral.

Louis Comfort Tiffany and John La Farge, American contemporaries of Morris, dominated stained-glass art in the United States at the turn of the century. Both men were skilled landscape painters and colorists, had fallen under the spell of twelfth- and thirteenth-century glass, and had discussed the art of glass with Madox Brown and Burne-Jones. Working independently, both men also developed–and patented–innovative techniques in glassmaking. They popularized the use of opalescent, iridescent glass whose texture and color modulations yielded superb pictorial effects and made the addition of painted details largely unnecessary. Both men achieved further effects by double- and triple-plating, by incorporating glass jewels and faceted chunks of glass, and by introducing drapery glass whose creases (formed while the glass is still soft) suggest the folds in a garment or the feathers in a wing.

The noted architect H. H. Richardson commissioned La Farge to design stained-glass windows for several of his projects, including Trinity Church in Boston. According to an enthusiastic article in the *Craftsman* magazine, the windows at Trinity "may be termed the opening of the American Revolution in decorative glass." Some of La Farge's secular windows introduced new subject matter into stained glass. An admirer of Oriental art, he borrowed for his own designs such

motifs as peacocks, butterflies, chrysanthemums, and carp. La Farge windows are in the collections of a number of museums, among them the Smithsonian Institution, the Metropolitan Museum of Art in New York, the Museum of Fine Art in Boston, and The Nelson-Atkins Museum of Art in Kansas City, Missouri.

Louis Comfort Tiffany described glass as "the most beautiful of all jewels." He experimented tirelessly with glassmaking, established his own glasshouse, and developed the iridescent glass he named Favrile, defining it as "hand-wrought." Like William Morris, he founded a decorative arts firm for handcrafted items. "We cover the whole field of decoration–frescoes and mural paintings, colored glass windows, marble and glass mosaics, wood-carving and inlaying, metal work, embroideries, upholsteries, and hangings," Tiffany advertised in 1893. That same year the Tiffany Glass and Decorating Company exhibited at the Columbian Exposition in Chicago and won a total of fifty-four medals. Tiffany continued to expand the range of items produced by his craftsmen, and he quickly achieved fame for the company's iridescent, hand-blown vases and its lamps with leaded-glass shades inspired by themes from nature. Leading museums in this country and abroad own examples of Tiffany glass. The finest collection of Tiffany windows is in the Morse Gallery of Art in Winter Park, Florida.

Stained-glass windows designed by La Farge and Tiffany are admired for their rich coloring and painterly expressiveness. Frank Lloyd Wright represents an opposite esthetic. In a description of his leaded-glass windows he said, "Most of them are treated as metal

'grilles' with glass inserted, forming a simple, rhythmic arrangement of straight lines and squares as cunning as possible as long as the result is quiet." His windows helped integrate indoors and outdoors. "Nothing is more annoying to me," he wrote, "than any tendency toward realism of form in window-glass, to get mixed up with the view outside."

Fernand Léger, Georges Rouault, Marc Chagall, and Henri Matisse are among the great twentieth-century easel painters who have contributed to the art of stained glass. Léger designed a monumental work–a bold, abstract mosaic of glass dalles–for the Church of the Sacred Heart at Audincourt. He also created the mosaic facade of the remarkable church at Plateau d'Assy, which contains work by a number of his contemporaries. Georges Rouault designed five richly colored windows for the church. He did not fabricate them himself, although as a boy he had been apprenticed to a master of stained glass and had helped restore thirteenth-century windows.

Several windows in the Assy church were designed by Marc Chagall; but the artist is especially noted for his Jerusalem Windows, in the synagogue of Hadassah-Hebrew University Medical Center. Chagall envisioned his windows, with their lyrical forms and glowing colors, as "jewels of translucent fire." Stained glass designed by Chagall appears also in the Cathedral of Metz, the Union Church of Pocantico Hills, and the United Nations Secretariat Building. His U.N. window, a memorial to Secretary-General Dag Hammarskjöld, is dedicated to Peace.

Henri Matisse considered his own masterpiece to be

the Chapel of the Rosary of the Dominican Nuns, in the Riviera hill town of Vence. Matisse devoted four years to the decoration of the chapel, designing everything from candlesticks and chasubles to fifteen large stained-glass windows. His goal was to create an integrated work of art. For the windows, with their intense coloring, he had glass manufactured, under his supervision, by Paul Bony of Paris. The repeated motif in the windows is a bold leaf shape reminiscent of the lively forms and colors in his paper cutouts–an art form he described as "painting with scissors." Matisse wanted the chapel to reflect "the lightness and joyousness of spring" and was delighted when a Dominican remarked: *"Enfin nous aurons une église gaie!"*

Artists working with stained glass continue to experiment with new techniques and new forms of expression. As Catherine Brisac points out in her authoritative history of the craft: "Stained glass is an art that still possesses the ability to surprise. It may no longer retain the same privileged position that it occupied during the Middle Ages, but it can still arouse strong emotions."

(Facing page) The business card of The Judson Studios incorporates the crest of the Arroyo Guild. The heraldic griffins symbolize four generations of the Judson family.

IV
The Judson Studios:
Looking Back, Looking Ahead

Stained glass is art and craft, is fine art and architecture. It's part of the fabric of the building and also an added artistic feature. ——*Walter W. Judson*

Since 1897 The Judson Studios has been a family enterprise. The current owners are Walter Judson, the president, and his wife Karen, who is secretary of the board. Their daughter, Lisa Judson-Connely, helped with sales until the birth of her first child. The Judsons' older son, Bill, meets with prospective clients, suggests themes and concepts for stained-glass windows, and sometimes selects the colors to be used. In addition to his work for the Studios, he is financial secretary of the Stained Glass Association of America. His brother,

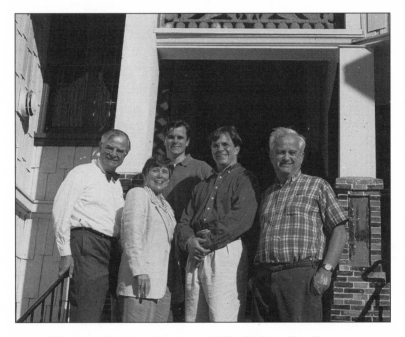

Photographed on the steps of The Judson Studios are
Walter Judson, his wife Karen, their sons David
and Bill, and Walter's brother, Douglas.

David, is organizing the archives of The Judson Studios and making a computer inventory of its files. Both brothers have special projects that recall the days of the Arroyo Guild. Bill and his wife, Pam, make handcrafted earrings and pendants from fragments of stained glass, and David arranges art exhibits in what once was the gallery of the College of Fine Arts. Still another member of the family–Walter's brother, Douglas–is in charge of the faceted-glass department.

"I used to sweep up the floors when we lived in an apartment above the studio," Walter Judson recalled in an interview with Richard Hoover. "Every school holiday, every summer, I worked at the studio. Basically, during all that period I did an apprenticeship. I could cut, I could glaze, I could install. I even tried my hand at painting." His understanding of the craft, his appreciation of the skills of his artisans, and his own profound knowledge of iconography are invaluable assets for the head of a stained-glass studio.

For helping in the shop as a boy, Walter received the princely sum of $1 an hour. In his grandfather's day, according to a 1908 ledger, apprentices made $5.00 a week; artists and craftsman made $12.50 to $20.00 a week; and W. H. Judson–president and sole owner–made $25.00. Scottish double-rolled cathedral glass was delivered to Los Angeles for 9¢ a foot in 1908 (compared to an approximate $4.00 today); and clients might pay up to $20.00 a square foot for a fine art-glass window. The old records show purchases of glass from L. C. Tiffany in New York, Kokomo Opalescent in Indiana, and Hartley Wood in England. The Judson Studios still orders glass from Kokomo and Hartley Wood. If he could use only

one glass on earth, Walter Judson once remarked, it would be from Hartley Wood. "Other antique glass is bright the way a soprano voice is bright," he says; "Hartley Wood colors are baritone." He was delighted, when visiting the company, to be shown several old cigar boxes with samples of purchases made by his grandfather at the beginning of the century.

Throughout its history, most windows created at The Judson Studios have been for religious institutions. In W. H. Judson's day the work was about two-thirds ecclesiastical and one-third secular. Now it is about 80 percent ecclesiastical: churches, chapels, synagogues, mortuaries, and cemeteries. "I am fascinated by man's aspirations to live a better life through the inspiration of an almighty force," Walter Judson observed. "Maybe that's why we do so much religious work." As an adjunct to his work at the Studios, he is a partner in Judson/Voorhees, which does interior design and general contract work for religious clients. "I believe in the gospel of stained glass and liturgical design," Judson says. "It's simply to lift people's hearts."

Between 1900 and 1920 the Studios did a relatively large amount of residential work compared to its residential commissions today. "People think we don't have time to take on small jobs," Judson explained. One recent, and somewhat unusual, small job was the creation of six Victorian-style windows and four cabinet lights (or sections) for a home wine cellar. By contrast is a huge new project, which is both residential and commercial: the fabrication of two hundred faceted-glass windows, in four different designs, for condominiums in Yokahama.

In addition to designing and fabricating new windows, The Judson Studios plays an important role in the conservation of stained glass that needs repair and renovation. The work may be as straightforward as restoration of stained-glass exit signs in the historic Orpheum Theater in downtown Los Angeles, or as complex as reconstruction of windows badly damaged in an earthquake. Recently the Studios completed the repair and restoration of glass in three Los Angeles landmarks: Frank Lloyd Wright's Hollyhock House, Saint Sophia Greek Orthodox Cathedral, and the Natural History Museum. Workers from the Studios also have removed and carefully documented windows in the 120-year-old St. Vibiana's Cathedral in Los Angeles, which was heavily damaged in the Northridge earthquake of 1994. Preservation work on the windows proceeds, pending construction of a new cathedral center. Walter Judson and shop superintendent Clyde Reimann have taught at restoration workshops, including the on-site restoration program at Cypress Lawn Memorial Park in Colma, a town just south of San Francisco. Cypress Lawn, described as one of the great art and architectural treasures of Northern California, boasts superb examples of stained glass, including gold and floral barrel-vault ceilings designed by Horace Judson.

In its first half century The Judson Studios employed only five or six craftsmen to design and fabricate stained-glass windows. In the 1950s, however, there was a tremendous upsurge in the number of churches being built and in the heightened demand for stained glass. The Judson Studios increased its staff to thirty in order to fill all the orders pouring in. With so many working

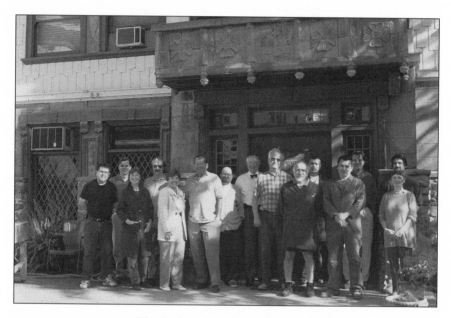

The Judson Studios artists, artisans,
and staff photographed in 1997.

on a project, however, consistency was a problem. To Horace Judson, high quality was more important than high volume, and he vowed that never again would the Studios employ more than fifteen people at a time. Walter Judson agrees. "If you go over fifteen," he says, "you'll make more money, but you can lose your reputation, too." In 1997 twelve people were working full time at The Judson Studios as artists, artisans, or apprentices. They come from various backgrounds, but all have a commitment to art. One special quality of The Judson Studios, the workers agree, is the relaxed and congenial atmosphere. The small number of artists and craftsmen makes for a close working relationship, with an understanding of what each person is doing, and a frequent sharing of tasks and talents. The workers take pride in their work, they are treated with respect, and no imperious supervisor watches over them.

In a discussion of changes he has seen in the industry, Walter Judson mentions increased use of the computer to archive designs, to recall them, and to combine the design elements in different ways. He mentions, also, new ways of making glass. Dichroic glass, a product of space-age technology, owes its magically shifting colors to ultra-thin layers of metal oxide molecules applied to the base glass. The astronauts who walked on the moon shielded their eyes with masks of dichroic glass. Now designers incorporate dichroic glass in windows because of the extraordinary effects it produces: transmitting one color, reflecting its complement, and shifting colors according to the angle at which it is viewed. "The one thing that no one will ever be able to change," says Judson, "is the fact that you're dealing with light

William Lees Judson and his art class in 1898.

coming through your medium, and that makes it unique and peculiar."

Another change that Judson sees–and welcomes–is the increasing number of women entering the field of stained glass. Women have played a small but important role at The Judson Studios since its founding. Bertha Judson Rundstrom, daughter of William Lees Judson, designed Tiffany-style windows and lampshades. The other women in the family would gather evenings to wrap copper foil around glass cut during the day for lamps, lighting fixtures, and copper-foil windows. Artist Lucile Lloyd created a number of stained-glass designs for the Studios in the late 1920s and early 1930s. After this no women were associated with the Studios as artists or craftsmen until the 1950s, when a great deal of mosaic work was being done. In 1980 Ann Pope MacDuff, a graduate of the Edinburgh College of Art, joined the Studios as an artist-craftsman. When she was made shop superintendent, the men grumbled until they discovered she could glaze faster than they could. In 1987 Ann MacDuff returned home to Northern Ireland, but she continues to do design work at long distance for the Studios. Pasadena artist Jae Carmichael, who also designs stained glass for the Studios, works closely with the artisans during every step of the fabrication process.

The rambling old building that houses The Judson Studios was one of the first Los Angeles landmarks to be designated a Historic-Cultural Monument. Not only is it the longtime center of a distinguished stained-glass atelier, but it has been home to the College of Fine Arts of the University of Southern California and headquar-

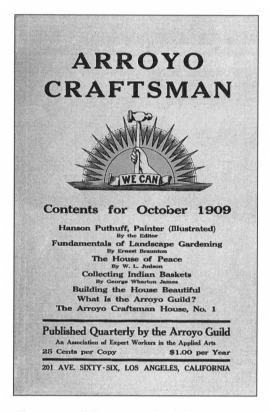

The cover of the one and only issue of the
Arroyo Craftsman, published by the Arroyo
Guild. Its crest, with the motto "We Can,"
is emblazoned above the entrance to
The Judson Studios.

ters of the Arroyo Guild of Fellow Craftsmen. Artist William Lees Judson played a role in all three institutions. He was founding dean of the College of Fine Arts, president of the Arroyo Guild, and a contributor to the one and only issue of the *Arroyo Craftsman*. He encouraged his sons to establish a stained-glass business in Los Angeles, and occasionally he provided them with designs.

Three of Judson's maxims, expressing his philosophy of art, decorate the walls of the glaziers' room. The room has another distinction: its own resident ghost. Several people claim to have seen the apparition, wearing a worker's apron and smoking a cigarette. They believe the ghost (a benevolent presence) is that of Lionel Judson, who was associated with the Studios for many years before his death nearly fifty years ago.

On the second floor of the Studios is the large gallery in which students and faculty of the College of Fine Arts once showed their work, and in which the Arroyo Guild sponsored lectures and craft exhibits. Future plans for the Studios include tranforming the gallery into an exhibition center for outstanding art with a spiritual quality. "There is no place like that now," Walter Judson points out. "Many churches would like fine art, but are unable to find it." The opening exhibit in the new gallery program featured the work of Los Angeles artist John August Swanson. His prints and paintings–often inspired by Biblical subjects–are characterized by brilliant color and fine detail and suggest the influence of medieval and Islamic miniatures and Russian iconography.

Adjoining the gallery is a library with an outstanding

Mosaic plaque with heraldic griffin, long an
emblem of the Judson family, marks the
entrance to The Judson Studios.

collection of books on the history and technique of
stained glass. The library room is notable also for its
windows inset with pieces of stained glass that consti-
tute a small anthology of styles dating back to the fif-
teenth and sixteenth centuries. Several of the heraldic
medallions depict the head of a griffin, a mythological
beast that William Lees Judson adopted for his family
crest and that subsequent generations have used as a
hallmark for the Studios. A griffin design also
announces the beginning of the Judson property. A
mosaic plaque featuring a griffin head is set in a stone
post above a bench where commuters used to wait for
one of the "Big Red Cars" of the Pacific Electric Railway.

In its centennial year The Judson Studios can look
back with pride on the thousands of buildings it has
enriched with the glowing beauty of stained glass.
Embarking now on a second century The Judson
Studios is guided still by a favorite maxim of William
Lees Judson: "Only the best is worthwhile," and by the
dictate of Horace Judson: "The true test of stained-glass
windows is that they live gloriously in the sun and die
beautifully with the darkness."

(Facing page) Mosaic version of the old Judson Studios logo.

Afterword:
A Personal View of Stained Glass
by Walter W. Judson

People often have asked me, "How has The Judson Studios lasted so long? What is your secret?" We are in the fourth and fifth generations, and The Judson Studios remains vital and is exploring new directions. Perhaps a key point is that the "new directions" are not as new as they seem, but are built on a foundation laid by three previous generations of the family and by generations of history. I believe that one of the strengths of The Judson Studios is our appreciation of the love and work of those who have gone before. The study of the past is the key to the future.

We are a studio–what the French call an atelier–rather than a shop based on the work of one person. I am prejudiced in favor of the studio setup not only because it is

what I grew up with, but also because I believe the studio is a place of cooperation and learning. It not only teaches the art and craft, but gives one the ability to work with other creative people in a creative medium. It allows the individual to know the joy of working with and for others. With this sort of interaction, including its occasional frictions, a person is transformed from an amateur, or lover of the art, to a professional, or one who can make a living doing stained glass.

When a number of artists work on a project, each one brings a new strength to the finished product. As a result, a studio design is less likely to become stale over the years. In the studio, also, new techniques and ideas can be forged–and probably roundly criticized in the beginning, as is anything new. In spite of the criticism, there is respect for the innovator. It is necessary for the innovator to be strong-willed and able to take criticism. When a technique has lasted for many generations, it is hard for the craft to accept a change.

Several years ago I compiled "Judson's Uncertain Rules of Stained Glass: a purely subjective and incomplete analysis of the craft." My four rules (and exceptions) appear below.

Rule One. Stained glass combines fine art and craft into a single medium. The argument between what is art and what is craft in stained glass is a fatuous thing. One person may design a window, and another person put it together. The same person may design and fabricate. The two processes are inextricably combined in stained glass. A good craftsperson must understand what is possible and necessary to put a good panel together. Stained glass is the combination of thought

and action. The artist pictures the window as it must be crafted, and the crafter pictures the window from the artist's desires expressed as a scale drawing or cartoon.

Exceptions to Rule One. You can argue that there is no art involved in leading up a diamond light, rectangles of clear glass, or some geometric pattern. True, there is a lot more craft than art involved here, but if the craft is poorly done, the finished panel is an artistic disaster. Besides, is only craft involved when you are selecting glass types and colors, or sizes and shapes of lead?

You can also argue that panels designed and fabricated for display in artificially lighted boxes and hung like paintings in homes and galleries are fine art and not craft. Nothing is further from the truth. The more intimate the setting, the more the necessity for craft excellence. When panels are seen close up, the details become as important as the art. Remember that as a rule artificial lighting is much softer than sunlight, and that poor workmanship shows up more when the light behind the panel is not so strong.

Rule Two. Stained glass is living light. The light is transmitted rather than reflected and the medium (glass) is a natural, not a synthetic product. This rule really makes stained glass unique. Starting with a scale drawing or sketch in color, we proceed to cartoon and pattern making. Then we cut the glass. But an odd thing happens. The colors that looked just perfect for the window in the sketch do not blend the same when they are transparent glass. Even if the sketch is made as a transparency, the colors are not the same. Colors at a distance have different strengths and act differently from each other. The classic example of this rule is that blue

expands and red recedes. At a distance a strong blue next to a ruby red produces a third color, purple, that is not really there. That is why in medieval windows the artists inserted whites and yellows when using strong blues and reds, as they often did. The French and English Gothic windows in which you may remember only reds and blues probably contain 30 to 50 percent whites and tints. You remember the reds and blues because the paler colors framed them for you, and they kept their strength because of this separation.

Many times when I have shown detailed, close-up color prints of windows in Chartres, Saint-Denis, and similar churches to people who have seen the windows in person, they did not recognize them because the whites and tints were so seemingly predominant. In much the same way your memory, and even your photographs, may trick you, depending on the time of day, the time of year, and the amount of pollution in the air when you saw the glass in a famous church. The same windows that looked quiet and mysterious on a winter's day may look almost wild and garish on the first days of summer. In the winter the blues may have been gray and frigid, but in the summer they are mobile and contain in their depths the heat of fire. The reds are solid and concise in winter and become deep and intense in the summer sun.

One of my favorite stories about stained glass being living light is set in medieval France. An old bishop is taking a group of children around the cathedral and pointing out various features which he thinks will make them better recall biblical and religious stories. In the midst of the excursion he stops and asks, "Who is a

saint?" One of his bright young students calls out, "Someone that God's light shines through!" The stained glass had taught its story well.

Rule Three. Stained glass colors are divided by opaque lines. Details and shadings are painted on with black or dark brown paints which are fired into the glass. Windows are held together by lead (or sometimes copper, epoxy, et cetera). This division between pieces creates a mosaic effect and defines each color more than in easel painting. The visual effect of the lead changes depending upon the amount of light coming through the window. A strong sun behind the window tends to overcome the black lines, and the glass pieces seem larger than they do in the early morning, with its cool, soft light.

A proof of Rule Three. During my years in the Studios I have come to know a great number of interesting and challenging people as client, advisor, and friend. One of the people I most admired for his intellectual ability, pastoral care, and ability to raise funds for good causes was the pastor of a large church in Phoenix, Arizona. The centerpiece of his new church was to be a faceted-glass window about fifteen feet wide and sixty feet high. We worked for years on the iconography, design, and coloring of the window. At one point he came to Los Angeles and we unrolled the full-size drawing, starting at the peak of the roof, down the roof, two stories to the ground, and then down the driveway. After the approvals and color selection and the cutting and casting of the glass into small sections, we trucked the window to Phoenix for installation.

The pastor was excited to see the workers arrive with

the window-laden truck and went out to meet them. Within a few minutes he had me on the telephone and was angry, to say the least. He told me he had bought glass, not a bunch of sand and epoxy; that the stuff was absolutely ugly, he would not let the panels off the truck, and would certainly never let them go into his church. After a protracted discussion on the importance of trusting creators–whether the creation be a sermon or a stained-glass window–we decided that it would be a good idea to take some of the panels off the truck and install the first fifteen feet or so from the floor up and the full width.

The pastor had a biblical quote for me when I called the next day: *Fiat lux*, "Let there be light" (Genesis 1:3). On the truck the panels did look all sand and epoxy, but light overcomes darkness, and the halation of the faceted glass reduced the opaque lines of epoxy.

Exception to Rule Three. You can have more than one color within a single piece of glass if you do not overdo it. The more traditional ways of having more than one color in a piece of glass are to use flashed glass or silver stain or to combine the two. The most-often used base glass for flashing is white. (Please note that to a glass worker, "white" means colorless, not milky.) Often in the old days ruby was blown as a very light veneer on top of white glass to allow the red to show up. To achieve the correct amount of color, ruby was made with copper and was very dark because the copper used was nearly pure metal. To cast this dark glass as thick as the other colors so it could be glazed into a panel was hopeless: the ruby would look black. Experiments were carried out and sometimes the dark ruby was streaked

with white; but later the workers discovered that if you started with a small ruby "draw" (lump of molten glass on the end of a hollow pipe) and dipped it into white glass and blew the sheet, the ruby draw would stretch very thin on the white, and the color would be brilliant.

To have two colors on this piece of ruby glass, all you have to do is etch through the ruby and expose the white. It is very simple today because we have acids and air compressors to help us do the work. The technique used by the medieval crafters was called "upbraiding." Some of the world's best examples are seen today in the British Museum. The work probably was done in stages. The first stage was rubbing sand or other type of grit on the surface, most likely using hard wood to work the sand. The second stage was done by the journeyman. It consisted of scraping the glass away with hard metal and fine sand to achieve details. It was even possible to shade from ruby through pink to white.

Silver nitrate is used today for staining glass yellow in varying shades, depending upon the density of the glass and its color. Metallic silver under the right conditions does pretty much the same thing. According to ancient stained-glass lore, around 1200 a monk was checking on the progress of a window being fashioned in a stained-glass workshop. One of the silver buttons on his sleeve broke off and fell upon a piece of lightly tinted glass with a simple design traced on it. Somehow the piece got into the kiln with the silver button on it. This would not be as far-fetched as we may think since often the decorated glass was collected until there were scores of pieces. The pieces were placed on trays and the trays stacked up. The kiln was built around the

stacked trays and fired. When the firing was complete and the kiln taken apart and the trays unstacked, the workers found a golden stain under the remnants of the button. Within a few years the process was known and widely used.

Staining is used in floral and vine motifs. Sometimes it is used to color a character's hair, and it is used in heraldic work. If you take a piece of ruby flashed on white and etch through the ruby, you will have red and white. If you then stain areas of the white, you can end up with red, white, and gold in a single piece and not break the rules. Note carefully, however, that to be in complete compliance with Rule Three, you must have a traceline between each of the color changes.

Another exception to Rule Three. You may use art streakies, like those made by Hartley Wood. Art streakies are sheets of glass blown with a single color (usually white) as a base, with one or two more colors added by winding molten glass on to the base glass as it is blown. No two sheets are alike, and the effect can be stunning to the viewer. Please note that "stunning" can either be seeing something beautiful or being kicked in the head by a mule.

Rule Four. Stained glass has transparency. Enamels should be used very sparingly and never on large pieces. Perhaps this is where you can really separate art glass and stained glass. Stained glass allows the glass to speak for itself. Art glass tends to use translucent color as opposed to transparent, and often the color and light values tend to be flat and even. Enamel is color applied to the surface and fired or baked in. This colored enamel nearly always takes the luster from the glass, no matter

how fine the art work technique is. Yet some of the finest work ever done on glass has used enamel. King's College Chapel in Cambridge has beautiful small roundels glazed into the aisle windows of the side chapels and rooms. The undercroft of Glasgow Cathedral has a fine collection of painted enamel lights, some of them tiny, most of them marvelously done. The one I like best shows David espying Bathsheba.

Most of these small enamels and the heraldic enamel work leave bits of raw glass to shine and sparkle. Even in the middle of this century, when people wanted their church windows to look like medieval work, the shading, or matting, applied to achieve this darkness was broken occasionally to allow the sparkle of the raw glass to show. It is ironic that the techniques used to make our windows look old probably never were used by the Gothic craftsmen. From many descriptions we know that these churches were veritable riots of color. The walls were plastered and painted, the windows were full of color, the ceilings were polychromed, and statues often were painted. The churches were places of color and life.

———————

There is something about glass that is exciting and fascinating because it seems so cool to the touch and so warm to the eye. In making stained glass we need idealism and pride. We need to remember that we are producing for the eyes and emotions of others, not ourselves alone. What we do must fit its surroundings. Design is a mutual education, client and crafter working together for the finest finished product.

(Facing page) Detail of the faceted-glass Moses window in
St. Mark's Episcopal Church, Van Nuys, California.

Gazeteer for the Judson Studios
by Walter W. Judson

This gazeteer, or geographical guide, lists representative work created by The Judson Studios in the past one hundred years. Each entry consists of the name of the city, the installation name and address, the year of installation, and a brief comment. Only California installations have been included, although our work appears throughout the United States and in a number of other countries.

We have only included work in public installations. In most cases all of the work at a site is that of The Judson Studios; however in a few instances you will see our work as well as that of another studio. A good example is All Saints Episcopal Church in Pasadena, where you will find Judson and Tiffany side by side.

PAINTING WITH LIGHT

ALHAMBRA

Emmaus First Lutheran. 840 South Almansor Street. Late 1950s to 1960s. Narrative, traditional windows, ashlar backgrounds.

Holy Trinity Episcopal Church. 412 North Garfield Avenue. 1960s to 1970s. Balcony has modern interpretation of ancient Trinity symbol in faceted glass. Aisles and clerestories are narrative with strong figures in leaded glass.

Mandarin Baptist Church. 201 N. First Street. 1996. Flowing contemporary leaded glass.

ALTADENA

Saint Mark's Episcopal Church. 1014 East Altadena Drive. Late 1940s through 1990s. Highly detailed leaded Neo-Gothic figure work. These aisle medallion windows were intended to become part of a Great West Window when the parish built its final church. Subjects range from the Apostles to Archbishop Tutu and Mother Theresa of Calcutta.

Mountain View Mausoleum/Pasadena Cemetery. 2300 North Fair Oaks Avenue. 1974 to 1984. The stained glass in the *Arbor of Light*, or Radiance Corridor, in Mountain View Mausoleum reflects off the polished marble walls and floor. The design of abstracted rose buds and blooms is the work of Dr. Jae Carmichael. The other glass in the mausoleum is from a number of different studios. The Pasadena Cemetery is the burial place of William Lees Judson, J. L. Judson, and Horace T. Judson.

ANAHEIM

First Christian Church. 520 West South Street. 1995. An example of a single central window designed to bring attention to the chancel.

Saint Michael's Episcopal Church. 311 West South Street. Chapel leaded late 1940s; main church faceted and etched 1960s to 1980s. Note detailed shields with broad faceted figures.

ARCADIA

Arcadia Presbyterian Church. First Avenue and Alice Street. Early 1960s. Faceted and leaded glass.

Our Savior Lutheran Church. 512 West Duarte Road. 1970s. Bold faceted symbols and mosaics.

ARVIN

Arvin Union Church. 500 Campus Drive. 1965. Faceted glass, full of symbols.

ATASCADERO

Saint William's Catholic Church. 6710 Santa Lucia. Faceted ashlar abstract.

BAKERSFIELD

All Saints Episcopal Church. 3200 Gosford Road. 1986. North elevation faceted-glass "Fruits of the Spirit." Note the use of color.

Saint Paul's Episcopal Church. 2216 Seventeenth Street. 1950s through 1970s. Narrative figure and symbolic work. Tiffany-style windows over balcony and altar.

BEAUMONT

Beaumont Presbyterian Church. 702 Euclid. Mid-1980s. Narrative figure work on contemporary quarry background.

BERKELEY

Saint Clement's Episcopal Church. 2837 Claremont. 1950 to 1990. Late Craftsman and Neo-Gothic English canopy work with iconography, often personal to the donor.

BEVERLY HILLS

Beverly Hills Community Church. 505 North Rodeo Road. 1950s and 1960s. Biblical narrative windows donated by well-known Hollywood stars. (Note the mouse in the Nativity added to the window at the request of donor Greer Garson.)

Mount Calvary Lutheran Church. 436 South Beverly Drive. 1982. Faceted glass; narrative work including figures and symbols.

BRAWLEY

Trinity Lutheran Church. 126 D Street. 1974. Faceted design with symbolism.

BUENA PARK

Saint Pius Catholic Church. 7691 Orangethorpe Avenue. 1994. Faceted glass flows through south wall of the sacrament chapel.

BURBANK

First United Methodist Church. 700 North Glen Oaks Boulevard. 1952 to 1955. Art Moderne in style, incorporating strong figures on a warm background.

First Presbyterian Church. 521 Olive Street. 1956 to 1971. Leaded glass in the narthex is a study of Jesus blessing a proletarian family. Faceted glass in the sanctuary is a teaching narrative, intensely blue in color.

BURLINGAME

Saint Paul's Episcopal Church. 415 El Camino Real. Late 1920s through 1956. If you like the English Craftsman style, you will find these windows and mosaics a true joy. The coloring in the larger windows is particularly interesting to study.

CANOGA PARK

Saint Martin's-in-the Fields. 7136 Winnetka Avenue. 1968 to 1980. Traditional and contemporary leaded and faceted glass. Especially notice the Te Deum in the west elevation.

CARMEL

The Carmel Presbyterian Church. Ocean and Junipero. 1967 to 1969. Biblical and Presbyterian Church history. Soft background colors with strong figures.

PAINTING WITH LIGHT

CARMICHAEL

Saint Michael's Episcopal Church 2140 Mission Avenue. 1966 to 1975. Faceted glass.

CHULA VISTA

Community Congregational Church. 276 F Street. 1950 to 1982. Neo-Gothic with contemporary iconography.

CLAREMONT

Claremont Presbyterian Church. 111 North Mountain. 1965. Faceted glass with iconography.

COLMA

Cypress Lawn Memorial Park. 1370 El Camino Real. 1994. Two contemporary floral leaded windows in Unit 8 designed by Dr. Jae Carmichael. The rest of the Memorial Park is a mixture of stained glass from notable stained glass studios all over the United States, including early Tiffany and Lamb Studios. Here you will find all descriptions of ceiling lights along with what would be best described as fantasy design and beautiful figure work.

COSTA MESA

South Coast Plaza, Jewel Court. 1973. Art Deco dome designed by Marion Sampler of Victor Gruen and Associates of Los Angeles.

DEL MAR

Saint Peter's Episcopal Church. 334 Fourteenth Street. 1943 to the present. The figure work in the aisle windows is a survey of Judson Studios artists for over half a century. A number of the windows contain small personalized symbols and vary in drafting and painting styles. Detailed information about the glass is available at the office.

EDWARDS AIR FORCE BASE

Air Force Flight Test Center Chapel One. 1967. The main chapel windows are abstract designs representing human aspiration and dreams of flight. The balcony window is a design exploration of experimental flight and a memorial to the pilots who flew the craft.

EL CENTRO

The Episcopal Church of Saints Peter and Paul. 528 South Fifth Street. 1971 to 1978. These rich faceted-glass windows are based on the canticle *"Benedicite, omnia opera Domini,"* from the Episcopal Book of Common Prayer. The rector of the church requested specifically that the window illustrating the line "O ye ice and snow, bless ye the Lord" be placed in the chancel, where he sat during the services, so he could think of cool things during the long El Centro summers.

First Presbyterian Church. Orange and Sixth Streets. 1956 to 1974. Detailed Neo-Gothic stained glass with figure work and symbolism. The painting style is meant to remind one of the cathedrals of Europe.

GAZETEER FOR THE JUDSON STUDIOS

Our Lady of Guadelupe. 11359 Coffield Street. 1967. Series of windows using figures and symbols from Catholic tradition to portray the attributes of the Blessed Virgin Mary.

EL SEGUNDO

Saint Anthony Parish. 710 East Grand Avenue. 1989. Broad flowing background with contemporary versions of traditional symbols.

Saint Michael's Episcopal Church. 361 Richmond Street. 1974 to 1980. Faceted-glass Pentecost window over the altar. Contemporary figure work and painting in the stained glass aisle windows.

ENCINITAS

Bethlehem Lutheran Church. 925 Balour Drive. 1989 to the present. Flowing, modern stained glass in color tints on the aisles. A stained glass cross behind the altar reflects on the polished tile around it.

San Dieguito United Methodist Church. 170 Calle Magdalena. 1980. Three faceted glass windows on a grand scale, dedicated to the Trinity. Local iconography.

ENCINO

Saint Nicholas Episcopal Church. 17114 Ventura Boulevard. 1957 to the present. A stained glass series in the clerestory dealing symbolically with the life of Jesus and the Anglican Church. Three windows apart from the series depict Our Lady of Walsingham, the murder of Saint Thomas of Canterbury, and Saint Nicholas resurrecting three boys murdered by a butcher and placed in a stew pot.

ESCONDIDO

Trinity Episcopal Church. 845 Chestnut Street. 1963. Faceted glass depicting Stations of the Cross.

FALLBROOK

Fallbrook Presbyterian Church. 463 South Stagecoach Lane. 1984. Great East Window of the resurrected Christ backed by the cross. The field and borders are in two-way glass, allowing the congregation to see the sky from inside. The same glass reflects the sky from the outside.

FONTANA

Fontana Community Church. 8316 Sierra Avenue. 1958 to 1979. Early work is Neo-Gothic. Newer work combines contemporary and traditional with interesting iconography.

FOWLER

First Presbyterian Church. 408 Merced Street. 1946 to 1986. Traditional colored and painted grisaille (mixed grays) and quarry work which casts "a mystic light that falls softly everywhere," according to the church pamphlet about the glass.

PAINTING WITH LIGHT

First Congregational Church. 2131 North Van Ness Boulevard. 1949 to 1953. Neo-Gothic with varying medallion shapes and background colors. Iconography ahead of its time, including ecumenical and ecology window themes, along with Bible and church history.

First Presbyterian Church. 1540 M Street. 1950s. Adaptation of older English styles with a teaching iconography: Old Testament, New Testament, and Presbyterian history.

Westminster Presbyterian Church. Santa Ana and Thorne. 1991. Use of faceted glass for strong, simple figures.

FULLERTON

Emmanuel Episcopal Church. 1145 West Valencia Mesa Drive. 1970 to 1984. Faceted glass windows used as symbolic banners in the main church. In the narthex is a bust of Christ with the powerful feeling of a stern and compassionate icon.

Saint Andrew's Episcopal Church. 1231 East Chapman. Mid-1950s to the present. A combination of contemporary and traditional in the church is carried out in the stained glass. Traditional stained glass figures, etched glass, and faceted glass. Note the oil wells and "Big A" in the west window.

Saint Jude's Hospital. 101 East Valencia Mesa. 1957 to 1984. Windows from 1957 are now in the offices of the chapel staff. The stained glass in the new main chapel is a notable example of contemporary work.

GARDEN GROVE

Saint Olaf's Lutheran Church. 12432 Ninth Street. 1969. Bright faceted glass. Notable is the inverted "Y" window over the chancel.

GLENDALE

Ann Ree Colton Foundation. 336 West Colorado. 1958 to 1994. Faceted glass in the original building, and a combination of faceted and leaded glass in the auditorium of the new building.

First Congregational Church. 2001 Canada Boulevard. 1976. Four faceted east aisle windows with detail and color in symbols and figures contrasted with grisaille in the background.

First Lutheran Church. 1300 East Colorado Boulevard. 1959 to 1960. Art Moderne narrative style designed to complement the postwar modern style of architecture. Pay close attention to the tracing and painting.

Glendale Presbyterian Church. 125 South Louise Street. 1920s to 1990. The faceted glass in the main church is notable for its size as well as design and color selection. The small chapel has glass from the old church in the finest English Craftsman style that W. H. Judson adapted to California. The education unit across the street has glass from the 1950s.

Saint Mark's Episcopal Church. 1020 North Brand Boulevard. 1949 to 1977. This is a church full of Judson traditional style designed by many different artists in the Studios. The subject matter varies from saints and angels to astronauts in space.

GAZETEER FOR THE JUDSON STUDIOS

Saint Matthew's Lutheran Church. 1920 West Glenoaks Boulevard. 1962 to the present. The nave is a wall of grisaille faceted glass interspersed with symbols of events from the Gospel of Saint Matthew.

Salem Lutheran Church. 1201 North Brand Boulevard. 1959. Combination of faceted glass, cathedral sheet glass, and jewel glass. These windows were an early experiment with new materials and color densities by Pasadena architect Culver Heaton.

HAWTHORNE

Saint George's Episcopal Church. 4679 West El Segundo Boulevard. 1977 to 1988. Detailed faceted windows, some mixed with clear glass in large windows.

HOLLYWOOD

First Presbyterian Church. 1760 North Gower Street. 1923 to 1940s. Main church has English Craftsman Gothic windows with Presbyterian iconography.

First United Methodist Church. 6817 Franklin Avenue. Early 1930s. Gothic Revival. The colored clerestory windows were meant to be temporary.

Saint Stephen's Episcopal Church. 6128 Yucca Street. 1950s. An example of modern design and painting.

HUNTINGTON PARK

Saint Matthias Parish. 3095 Florence Avenue. Early 1950s. Revival of grisaille Gothic with symbols and figures. Note the balance between architecture and stained glass.

INDIO

Saint John's Episcopal Church. 45-391 Deglet Noor Street. 1950s. Heavily painted French Gothic Revival work.

INGLEWOOD

Inglewood Park Mausoleum. 720 East Florence Avenue. First half of the twentieth century. Many ceiling lights in the mausoleum corridors, and landscapes at the ends of the corridors. The newer landscapes are by other firms.

IRVINE

Shepherd of Peace Lutheran Church. 18182 Culver Drive. 1990. Harmony of contemporary architecture and faceted glass.

LA CANADA FLINTRIDGE

Church of the Lighted Window. 1200 Foothill Boulevard. This church is a small museum of faceted and stained glass done throughout the century. There are windows by Tiffany in the parish hall. The aisles are the work of The Judson Studios, Los Angeles Art Glass, and a French firm (which did the north aisle faceted glass). The "Lighted Window" maker is unknown.

Crescenta-Canada Family YMCA. 1938 Foothill Boulevard. 1968. The meditation chapel is an interesting curiosity. The dalles beside the structural columns are the same glass used at the Air Force Academy Chapel in Colorado Springs.

PAINTING WITH LIGHT

LAGUNA BEACH

Saint Mary's Episcopal Church. 428 Park Avenue. 1950s to 1960s. Narrative windows using traditional figures and contemporary backgrounds.

LAGUNA HILLS

Lutheran Church of the Cross. 24231 El Toro Road. 1967 to 1990. A job still in progress. Powerful mosaic more than twenty feet tall behind the altar.

Saint George's Episcopal Church. 23802 Avenida de la Carlotta. 1969 to 1982. Detailed heraldic and figure windows; two large traditional mosaics on the north interior wall.

LA JOLLA

Bishop's School Chapel. 7607 La Jolla Boulevard. Early 1930s on. Traditional figure and heraldic windows. The chapel itself is an architectural jewel.

La Jolla Evangelical Lutheran Church. 7111 La Jolla Boulevard. 1952 to 1981. Neo-Gothic narrative windows.

La Jolla Presbyterian Church. 7715 Draper Avenue. 1949 to 1965. The scale of the architecture and stained glass gives the feeling of a Gothic church. The windows are intricate and tight in design. The color is definitely French inspired.

Mary, Star of the Sea Catholic Church. 7727 Girard Avenue. 1937 to 1969. A true jewel of a church, with fine glass.

Union Congregational Church. 1216 Cave Street. 1955 to 1964. An array of small mosaic-style stained glass windows in the clerestory.

LOMPOC

Saint Mary's Episcopal Church. 2800 Harris Grade Road. 1957 to the present. Traditional and contemporary stained glass in a modern church.

LONG BEACH

Christ Lutheran Church. 6500 East Stearns Street. 1980 to 1993. Detailed, faceted glass.

First Baptist Church. 1000 Pine Avenue. 1953 to 1983. Gothic Revival in a modern church. Note especially the Gothic Revival work in the narthex and the art glass Ascension in the old chapel.

First United Methodist Church. 507 Pacific Avenue. 1910s to 1975. The old art glass window of the Christ in the Temple was used as the illustration on the W. H. Judson Art Glass Company business card around the time of World War I.

Los Altos United Methodist Church. 5950 East Willow Street. 1967. Note the faceted glass chancel window.

Memorial Hospital Chapel. 30 Linden Avenue. 1961. Modern-style window making up the exterior wall of the chapel.

North Long Beach United Methodist Church. 5600 Linden Avenue. 1969 to 1972. Narrative faceted glass.

Saint Gregory's Episcopal Church. 6201 East Willow Street. 1967 to 1972. Faceted-glass figures. Note especially the narrow Stations of the Cross.

Saint Joseph's Catholic Church. 6220 East Willow Street. 1976. Traditional figure work in faceted glass.

Saint Luke's Episcopal Church. 525 East Seventh Street. 1920s to 1982. Traditional grisaille leaded glass–some of it all that was saved from the ruined church after the 1933 Long Beach earthquake. One of the notable features is the Judson mosaic around the font.

Saint Thomas Episcopal Church. 5306 Arbor Road. 1960 to 1964. The east window is an early faceted glass interpretation of a verse from the Psalms: "Blessed is the man that maketh the Lord his trust." The triangular south windows are traditional scenes from the life of Saint Thomas of Canterbury.

Los Angeles

Faith United Presbyterian Church. 115 North Avenue 53. 1920s. An example of English Craftsman style in Southern California.

First Congregational Church. 540 Commonwealth Avenue. 1920s to 1950s. This church is worth a visit from anywhere in the world for its Gothic Revival architecture and stained glass. The iconography and the detail and craftsmanship of the glass is notable throughout the church.

First Nazarene Church. 221 South Juanita Avenue. 1960s. Traditional narrative Biblical illustration.

Grace Presbyterian Church. 1500 North Avenue 53. 1960. Early trendsetting faceted glass work.

Immaculate Heart of Mary. 4950 Santa Monica Boulevard. 1980s. Strong contemporary figure work in the clerestory.

Memorial Branch Library. 4625 West Olympic Boulevard. 1930 and 1996. Heraldic and quarry design.

Natural History Museum of Los Angeles County. Exposition Park. 1913; releaded in 1995. Large dome in English Craftsman style using opalescent glass.

Old Plaza Church (La Placita). 100 West Sunset Boulevard. 1977. Modern balcony window of Saint Anthony Claret; chancel mosaics.

Optimist Home for Boys Chapel. 6957 North Figueroa Avenue. 1959. Modern-style illustrative windows of heroes of the Bible.

Saint Agatha Catholic Church. 2610 South Mansfield Avenue. 1973. Faceted glass in a mission-style church. Iconography for a diverse community. Most notable is the north rose window of the Martyrs of Uganda.

Saint Agnes Catholic Church. 1404 West Adams Boulevard. 1900 to 1950s. The earliest glass was moved from the original church and represents some of the first ecclesiastical work of the Judsons in Los Angeles.

Saint Bede's Episcopal Church. 3590 South Grand View Boulevard. 1980 to the present. The clerestory windows depict the life of Christ in a bold, colorful, modern style.

Saint Francis Episcopal Church. 3621 Brunswick Avenue. 1967 to 1982. Contemporary stained glass depicting the life of Saint Francis of Assisi.

Saint James Episcopal Church. 3903 Wilshire Boulevard. 1928 to the present. The windows in this church represent three generations of The Judson Studios' work. The altar and baptistery windows by Walter H. Judson pay homage to the English Craftsman style; the 1950s windows by Horace T. Judson pay homage to the French Gothic and English Gothic Revival; the newer windows by Walter W. Judson show contemporization of the traditional Gothic. Note the faceted glass cross in the parish hall.

Saint Jerome's Catholic Church. 5550 Thornburn Street. 1990 to the present. The chevron-shaped window behind the chancel complements the architecture. The narthex glass is by Paul Phillips, a former designer for the Judson Studios.

Saint John's Episcopal Church. 514 West Adams Boulevard. 1920s to the present. This church, done in the northern Italian style, is worth a special visit to see not only the glass by Judson and many others, but also to see the mosaics. Note especially the Byzantine Lady Chapel mosaics done in 1967.

Saint Mary's Episcopal Church. 961 South Mariposa Avenue. 1969. Contemporary stained glass with a fascinating iconography, including lawn mowers, barbed wire, and a Snoopy in the Crucifixion window.

Saint Mary of the Angels Anglican Catholic Church. 450 Finley Avenue. The Saint Genesius circle window is by The Judson Studios.

Sephardic Temple Tifereth Israel. 10500 Wilshire Boulevard. 1993. Designed by the Israeli artist Raphael Abecassis, this entry window depicts the Sephardic heritage.

Wilshire Boulevard Christian Church. 634 South Normandie Avenue at Wilshire Boulevard. 1926. This is an example of the attempt to make a church look and feel like the medieval.

Trinity Baptist Church 2040 West Jefferson Boulevard. 1987. Bright ashlar with symbols.

MODESTO

Saint Dunstan's Episcopal Church. 3242 Carver Road. 1975 to 1985. Detailed faceted glass.

MONROVIA

First Presbyterian Church. 101 East Foothill Boulevard. 1910s to 1988. An example of art glass.

Saint Luke's Episcopal Church. 415 Wild Rose Avenue. 1925 to 1997. A display of traditional glass, including a clerestory window of C. S. Lewis.

MONTEREY

Monterey United Methodist. 1 Soledad Drive. 1995. Contemporary faceted glass.

MONTEREY PARK

Chinese Evangelical Free Church. 1111 South Atlantic Boulevard. 1993. Faceted glass in unusual configuration over baptistery.

GAZETEER FOR THE JUDSON STUDIOS

MOORPARK

Holy Cross Catholic Church. 13539 Adlena Place. 1993. A mixture of faceted, stained, and etched glass.

NEWPORT BEACH

Saint James Episcopal Church. 3209 Via Lido. 1950s. Traditional figures set on a contemporary background.

NORTH HOLLYWOOD

Emmanuel Lutheran Church. 11919 Oxnard. 1969 to 1995. Dramatic, colorful faceted glass.

Saint Matthew's Lutheran Church. 11031 Camarillo Street. 1955 to 1961. Contemporary leaded. Soft color.

NORWALK

Trinity Lutheran Church. 11507 Studebaker Road. 1973 to 1983. Sturdy faceted glass to go with the architecture.

NOVATO

Good Shepherd Lutheran Church. 1180 Lynwood Drive. 1980. Leaded glass, with one faceted window. The aisle windows were designed with some clear glass so as not to interfere with the view.

OJAI

Saint Andrew's Episcopal Church. 409 West Topa Topa Drive. 1975. Contemporary faceted glass.

ONTARIO

First United Methodist Church. 918 North Euclid Avenue. 1956. An example of traditional stained glass.

ORANGE

Fairhaven Memorial Park. 1702 East Fairhaven Avenue. 1960. Halsell Chapel, in the Memorial Park, has grisaille work in the French manner.

First Presbyterian Church. 191 North Orange Street. 1946 to 1987. Narrative faceted glass. Interesting experimental window in the narthex.

Saint John's Lutheran Church. 154 South Shaffer Street. 1915. Not Judson work, but a wonderful example of art glass and fine enamel painting.

PALM SPRINGS

Our Savior Lutheran Church. 1020 East Ramon Road. 1982. Detailed faceted symbolism.

Palm Springs Community Church. 284 South Cahuilla Road. 1961. Among the early large faceted installations. Broad, strong design.

Saint Paul of the Desert. 125 West Alameda. 1971 to 1974. Faceted glass. The symbols and figures stand out against an opaque background.

PAINTING WITH LIGHT

PARADISE

Saint Nicholas Episcopal Church. 5872 Oliver Road. 1982 to 1987. Geometric leaded glass with traditional symbolism.

PASADENA

All Saints Episcopal Church. 132 North Euclid Avenue. First quarter of the century. Examples of English Craftsman Gothic, along with American art glass-style work by Judson and Tiffany.

Church of the Angels, Episcopal. 1100 North Avenue 66. 1880s. This is not Judson work, but the glass architecture and artwork are Victorian style at its best.

First Baptist Church. 75 North Marengo. 1920s to 1974. Simplified Gothic church, with half a century of Judson stained glass. Interesting iconography. Note the aisle windows especially.

Hill Avenue Grace Lutheran Church. 73 North Hill Avenue. 1948 to 1990. Leaded and faceted work.

Holliston Avenue Methodist Church. 1305 East Colorado Boulevard. Turn of the century. Art glass.

Lincoln Avenue Baptist Church. 1160 Lincoln Avenue. 1976. Colorful contemporary faceted glass.

Pasadena Presbyterian Church, Freeman Chapel. 54 North Oakland. 1954. Intricate French Gothic-style glass.

Westminster Presbyterian Church. 1757 North Lake Avenue. 1920s to 1991. Gothic-style work. The rose windows were done to emulate the old Gothic cathedrals of Europe.

PIEDMONT

Piedmont Community Church. 400 Highland Avenue. 1951 to 1966. Traditional leaded glass.

POMONA

Saint Paul's Episcopal Church. 242 East Alvarado Street. 1920s to 1990. A collection of work by three generations of artists of The Judson Studios.

Trinity United Methodist. 676 North Gibbs. 1954 to 1970. Contemporary Gothic stained glass.

POWAY

Lutheran Church of the Incarnation. 16889 Espola Road. 1981. Lively and colorful faceted glass.

Saint Bartholomew's Episcopal Church. 16275 Pomerado Road. 1980. Broad faceted glass with iconography worth studying. (We meet C. S. Lewis again.)

Saint Michael's Catholic Church. 15546 Pomerado Road. 1993. Strong figures and good iconography. Design work by Bob Rambusch, the famous liturgical designer from New York.

RANCHO PALOS VERDES

Saint-Peter-by-the-Sea Presbyterian Church. 6410 Palos Verdes Drive South. 1970. Detailed iconography and strong figure windows in faceted glass in the sloping roof.

REDLANDS

First Baptist Church. 51 West Olive Avenue. 1950s. Solid, traditional, narrative stained glass.

First Lutheran Church. 1207 West Cypress Avenue. 1966 to 1990. Faceted glass.

Redlands University Chapel. 1920s. The large chancel window was Walter H. Judson's pride and joy.

Trinity Episcopal Church. 419 Fourth Street. 1920s to 1976. Traditional English Gothic, to suit the architecture. An English firm did the west window.

REDONDO BEACH

Christ Episcopal Church. 408 South Broadway. 1980. The west window is especially notable.

Immanuel Lutheran Church. 706 Nob Hill. 1968 to 1973. Leaded and faceted work.

Lutheran Church of the Resurrection. 330 Palos Verdes Boulevard. 1963. Modern leaded work.

Saint Andrew's Presbyterian Church. Pacific Coast Highway at Avenue D. 1963. Painted modern style, with biblical iconography.

REDWOOD CITY

Redeemer Lutheran Church. 468 Grand Street. 1950s. Traditional figure work on ashlar background. The painting is fairly heavy to give the impression of great age.

RICHMOND

Grace Lutheran Church. 2369 Barrett Avenue. 1972 to 1981. Faceted glass work with historical iconography.

RIDGECREST

First Baptist Church. 1350 South Downs. 1991 to 1993. Abstract faceted glass.

Grace Lutheran Church. 502 Norma. 1980. Flowing faceted altar window.

Our Savior Lutheran Church. 731 North Sanders. 1961. Early faceted glass.

RIVERSIDE

All Saints Episcopal Church. 3847 Terracina Drive. 1948 to 1966. Detailed stained glass in the church and floral faceted glass in the chapel.

Calvary Presbyterian Church. 4495 Magnolia. 1950s. Neo-Gothic work. Note particularly the grisaille balcony rose and lancets.

Eden Lutheran Church. 4725 Brockton Avenue. 1953 to 1966. Narrative stained glass in the church and faceted glass in the tower.

First Congregational Church. 3755 Lemon Street. Open Neo-Gothic.

Immanuel Lutheran Church. 5545 Alessandro Boulevard. 1976. Modern faceted, with symbols.
Saint Michael's Episcopal Church. 4070 Jackson Street. 1967 to 1972. Spanish Gothic-influenced stained glass.

ROLLING HILLS ESTATES

United Methodist Church. 26438 Crenshaw Boulevard. 1994. Light, uplifting glass in chancel.

ROSEMEAD

Saint Joseph Salesian Youth Renewal Center Chapel. 8301 Arroyo Drive. 1967. The chapel walls are modern German-influenced stained glass with interesting symbolism.

SACRAMENTO

All Saints Episcopal Church. 2076 Sutterville Road. 1960s. Traditional stained glass.
Woodside Church of the Seventh-Day Adventists. 3300 Eastern Avenue. 1972. Abstract, warm faceted glass.

SAN BERNARDINO

First Christian Church. 1001 North Arrowhead Avenue. 1970 to 1984. Large-scale faceted glass windows.
First Congregational Church. 3041 North Sierra Way. 1957 to 1981. Modern painted stained glass.
Lutheran Church of Our Savior. 5050 North Sierra Way. 1966 to 1978. Modern faceted glass to complement a modern angular building.
Saint Francis of Assisi Episcopal Church. 2855 Sterling Avenue. 1969 to 1977. Traditional design in faceted glass.
Saint John's Episcopal Church. 1407 Arrowhead Avenue. 1940s to 1980. Traditional stained glass narrative iconography.

SAN DIEGO

All Saints Episcopal Church. 625 Pennsylvania Avenue. 1955 to 1967. Note the Te Deum window in the west clerestory and the saints of church history in the aisle clerestories.
Diocese of San Diego Pastoral Center Chapel (Roman Catholic). 3888 Paducah. 1966. Best described as "glassy." Geometric grisaille aisle windows.
Grace Evangelical Lutheran Church. 3993 Park Boulevard. 1928 to 1973. The west and east windows won the AIA award for design when they were installed in 1928. The balance of the windows are an assortment of traditional stained glass.
Saint Paul's Episcopal Cathedral. 2728 Sixth Avenue. 1950 to 1967. Said to be the finest Gothic-style stained glass on the West Coast. Along with the First Congregational Church in Los Angeles it ranks as the work of which Horace T. Judson was most proud.

GAZETEER FOR THE JUDSON STUDIOS

SAN FERNANDO

First Presbyterian Church. 1102 Fourth Street. 1949 to 1966. An example of 1950s style.

SAN FRANCISCO

Donatello Hotel. 501 Post Street. 1980. Art glass dome over drive-in courtyard.

Stanford Court Hotel. 905 California Street. 1970. American-style art glass domes in a contemporary style. Note particularly the dome in the drive-in courtyard.

SAN GABRIEL

Church of Our Saviour. 535 West Roses Road. 1920s to 1980. Mostly Judson work over many decades. The "Christ with the Children Window" is an example of the mixture of English and American Craftsman style. Designed by Frederick Wilson, who came to Judsons after working many years at Tiffany in New York.

Trinity Lutheran Church. 6882 North San Gabriel Boulevard. 1971 to 1975. Faceted glass is by Judson.

SAN JUAN CAPISTRANO

South Coast Christian Assembly. 31501 Avenida Los Cerritos. 1996. Contemporary circle windows.

SAN LUIS OBISPO

Central Church of Christ. 3172 Johnson. 1982. Six faceted glass windows in broad scale and soft color.

Mount Carmel Lutheran Church. 1701 Fredericks Street. 1973. Strong faceted symbol windows.

United Methodist Church. 1515 Fredericks Street. 1979. The east end of the sanctuary is all faceted glass in a moving modern design.

SAN MARINO

Community Church. 1750 Virginia Road. 1947 to 1962. Notable for the design, coloring, and iconography. Do not miss the grisaille work in the side chapel.

Saint Edmund's Episcopal Church. 1175 San Gabriel Boulevard. 1952 to 1983. The balcony rose window is a true geometric rose, not just a circle window. See the small chapel for contemporary Gothic.

SAN PEDRO

First Presbyterian Church. 731 South Averill Avenue. 1997. Stained-glass symbols designed to suit a 1950s modern church.

SANTA ANA

First Baptist Church. 1010 West Seventeenth Street. 1957. Modern stained glass aisle windows illustrating the Beatitudes. Also note the east radiance window.

First Congregational Church. 2551 Santiago Avenue. 1961. Rich, darkly painted traditional stained glass.

First United Methodist Church. 609 Spurgeon Street. 1965. Modern stained glass; ashlar background.

First Presbyterian Church. 601 North Sycamore. 1920s to 1992. Most of the work is from the 1920s. The two side lancets of the east window are the newest work.

Saint Joseph's Catholic Church. 717 North Minter Street. 1948 to 1954. Traditional windows to meet the thinking of the day.

Saint Peter's Lutheran Church. 1510 North Parton. 1964 to 1974. Note the iconography and painting of this stained glass.

SANTA BARBARA

All Saints by the Sea (Montecito) Episcopal Church. 83 Eucalyptus Lane. 1920s to 1964. An interesting mix of Judson Studios work with others, including very old art glass.

Emanuel Lutheran Church. 3721 Modoc Road. 1952 to 1987. The stained glass was moved from the old church. The faceted glass over the chancel is as bold as the architecture of the new church.

First Christian Church. 1915 Chapala. 1989. An example of simple quarry windows with symbols fitted exactly to the surroundings.

Trinity Episcopal Church. 1500 State Street. 1945 to 1979. English canopy windows adhering to the architectural style. Note the altar window and also the one aisle window designed by Frederick Wilson when he worked at another studio in Los Angeles.

SANTA MARIA

Grace Lutheran Church. 423 East Fesler Street. 1988 to 1997. Powerful narrative leaded symbolism. The sketches were accepted and approved twenty-five years before work began on the first windows.

Saint Peter's Episcopal Church. 402 South Lincoln Street. 1932 to 1992. A series of traditional windows. A favorite is Saint Juliana of Norwich with her cat.

SANTA MONICA

First United Methodist Church. 1008 Eleventh Street. 1953 to 1959. Traditional stained glass work.

Mount Olive Lutheran Church. 1343 Ocean Park Boulevard. 1962 to 1987. A mixture of faceted and stained glass.

Trinity Baptist Church. 1915 California Street. 1948 to 1987. Mix of Judson and Cummings of San Francisco in the modern style.

SANTA PAULA

First United Methodist Church. 133 North Mill Street. 1951 to 1954. Modern church with a rose window and grisaille aisles.

Saint Paul's Episcopal Church. 117 North Seventh Street. 1993. Abstract faceted work.

GAZETEER FOR THE JUDSON STUDIOS

SEAL BEACH

Leisure World Community Church. 14000 Church Place. 1977 to 1988. Narrative stained glass in the clerestory corona and etched glass in the chapel.

Redeemer Lutheran Church of Leisure World. 13560 St. Andrews Drive. 1965 to 1976. Narrative leaded glass.

SHERMAN OAKS

Congregational Church of the Chimes. 14115 Magnolia Boulevard. 1971 to 1986. Note the chapel windows. The north window in the main church is bold, contemporary stained glass work.

SIERRA MADRE

Mater Dolorosa Retreat Center Chapel. 700 North Sunnyside Avenue. 1949 to 1969. Narrative faceted glass on the aisles. Note the stained glass circle in the south clerestory.

SILVER LAKE (LOS ANGELES)

Silverlake Community Presbyterian Church. 2930 Hyperion Street. 1957 to 1963. Modern ashlar background with traditional figures.

SIMI VALLEY

United Methodist Church. 2394 Erringer Road. 1985 to 1986. Strong faceted glass work.

SOUTH GATE

Saint Margaret's Episcopal Church. 4704 Tweedy Boulevard. 1953 to 1979. Traditional English-style grisaille for traditional English architecture.

SOUTH PASADENA

Calvary Presbyterian Church. 1050 Fremont Avenue. 1920s. Craftsman-style stained glass. Of particular note is the balcony Nativity window.

Saint James Episcopal Church. 1205 Fremont Avenue. 1941 to 1970. Detailed Gothic-style work. Note the rose window on the east clerestory, done in England when the church was built.

South Pasadena Public Library. 1100 Oxley Street. 1981. Contemporary stained glass at entry and in ceiling.

STOCKTON

Saint Bernadette's Catholic Church. 2544 Plymouth Road. 1989 to 1997. Simple clerestory windows brighten the church.

Saint John the Evangelist Episcopal Church. 117 East Miner Avenue. 1976 to 1995. The Judson work is in the lower clerestory. There is work by a number of other studios, from art glass to fine Neo-Gothic.

STUDIO CITY

Harvard-Westlake School. 3700 Coldwater Canyon Avenue. 1962. Windows illustrating hymns, with the iconography largely thought out by the students.

PAINTING WITH LIGHT

TEHACHAPI

Saint Jude's Episcopal Church. 1200 South Curry. 1992. Note the east window.

TEMPLE CITY

First Lutheran Church. 7123 East Broadway. 1970 to 1976. Abstract faceted glass clerestory windows depicting the Apostles' Creed.

THOUSAND OAKS

Redeemer Lutheran Church. 667 Camino Dos Rios. 1994. Light, open stained glass symbol windows.

Saint Patrick's Episcopal Church. 1 Church Road. 1973 to 1983. Strong faceted glass windows over the two main entries. The aisle windows are an intricately worked out iconography of church history from the Acts of the Apostles through the twentieth century.

TOLUCA LAKE (LOS ANGELES)

United Methodist Church. 4310 Cahuenga. 1958 to 1993. Traditional figure windows in a New England-style church.

TORRANCE

Ascension Lutheran Church. 17910 Prairie Avenue. 1968. Dramatic, sweeping faceted chancel window.

Christ the King Lutheran Church. 2706 West 182 Street. 1965. Faceted glass. Note especially the "I am" window.

First United Methodist Church. 1551 Prado Avenue. 1961. Symbolic faceted glass in a modern architectural setting.

Hope United Methodist Church. 3405 Artesia Boulevard. 1985. Abstract leaded figure work in chancel.

Saint Andrew's Episcopal Church. 1432 Engracia Avenue. 1958 to 1985. Mix of leaded work. Note particularly the etched doors in the entries.

UNION CITY

Masonic Homes of California, Siminoff Center. 34400 Mission Boulevard. 1990. Flowing leaded glass with Masonic symbolism.

UPLAND

First Presbyterian Church. 869 North Euclid Avenue. 1985. Abstract leaded work.

First United Methodist Church. 262 North Euclid Avenue. 1932 to 1959. Leaded work in the church and fellowship hall.

VALENCIA

Saint Stephen's Episcopal Church. 24901 Orchard Village Road. 1996. East and west clerestory leaded abstract windows.

VAN NUYS

Saint Mark's Episcopal Church. 14646 Sherman Way. 1973 to 1995. Faceted glass aisle windows done in icon style. (George Burns donated the Moses window.)

GAZETEER FOR THE JUDSON STUDIOS

VENTURA

Community Presbyterian Church. 1555 Poli Street. 1929 to 1972. Gothic Revival stained glass.

Saint Paul's Episcopal Church. 3250 Loma Vista Road. 1958. Modern stained glass with dramatic painting technique.

VISALIA

First Presbyterian Church. 215 North Locust. 1965. Traditional figures and symbols set against a contemporary background.

Saint Paul's Episcopal Church. 120 North Hall Street. 1949 to 1986. Judson is responsible for the east and west windows and most of the aisles, but this beautiful church also has Victorian painted windows, as well as art glass-style windows from the turn of the century.

Seventh-day Adventist Church. 1310 South Woodland Drive. 1970. Two faceted glass windows.

VISTA

First Lutheran Church. 342 Eucalyptus Avenue. 1965. Faceted glass in the central tower. This was an experimental architectural design.

WESTCHESTER

Westchester Lutheran Church. 7831 Sepulveda Boulevard. 1963. The faceted-glass aisles are a simple progression of colors. The entire chancel is a faceted glass abstract design symbolizing the Apostles' Creed.

WEST COVINA

Immanuel First Lutheran Church. 512 South Valinda Avenue. 1970. Two faceted glass windows depicting the Crucifixion and Resurrection.

WEST LOS ANGELES

Saint Sebastian's Catholic Church. 1453 Federal Avenue. 1971. Faceted glass east wall.

WESTMINSTER

First Presbyterian Church. 7702 Westminster Avenue. 1967. Stained and faceted glass combined.

WESTWOOD

Saint Alban's Episcopal Church. 580 Hilgard Avenue. 1954 to 1977. Gothic-style. The clerestory iconography is from the Book of Revelations. Anglican Church history in the aisles.

Westwood Hills Christian Church. 10808 Le Conte Avenue. 1949 to 1970. Note especially the west balcony heraldic window.

Westwood Hills Congregational Church. 1989 Westwood Avenue. 1969 to 1996. Faceted glass in the clerestory. Note the old art glass windows in the social hall.

Westwood Presbyterian Church. 10822 Westwood Boulevard. 1953 to 1966. Neo-Gothic work.

East Whittier Christian Church. 9951 South Mills Avenue. 1966. Note the faceted glass in an interesting double nave church.

First United Methodist Church. 315 East Bailey. 1952 to 1959. Fine Neo-Gothic. Note painting techniques.

Rose Hills Memorial Park. 3900 South Workman Mill Road. Most recent 1972. Ceiling lights throughout the mausoleums. 1972 work was geometric faceted glass.

Saint Andrew's Lutheran Church. 11345 Miller Road. 1965 to 1973. Strong faceted glass.

Saint Bruno's Catholic Church. 15740 Citrustree Road. 1981. Traditional figures and symbols on a warm, abstract background.

Saint Matthias Episcopal Church. 7056 South Washington Avenue. 1929 to 1984. Note the balcony circle window, which is quite modern.

Whittier Presbyterian Church. El Rancho at Broadway. 1948 to 1962. Contemporary leaded work in the church nave. Note the iconography.

YUCAIPA

Good Shepherd Lutheran Church. 34215 Avenue E. 1991. Bright, simple, abstract leaded work with symbolism.

(Facing page) Workers at The Judson Studios posed with Congressman Edgar Hiestand in 1952. *Photo by Larry Harmon.*

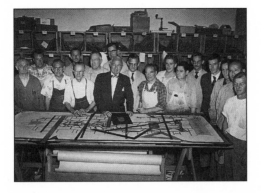

A Centennial Roster

1. FAMILY MEMBERS WHO HAVE WORKED AT THE JUDSON STUDIOS

Five generations of the Judson family have been associated with The Judson Studios. The first generation is represented by William Lees Judson, who occasionally designed stained glass for the Studios. The beginning of the Studios, however, dates back to the second generation of the family and Judson's sons: Walter Horace (the founding president), Lionel (who became vice-president), and Paul (who served as accountant). Their sister, Bertha Judson Rundstrom (who was an artist), worked in the Studios, as did Walter Horace's wife, Mabel. George Wiley, who married William Lees Judson's youngest daughter, Pearl, also worked in the Studios.

Three cousins–Horace Judson, J. William Rundstrom, and Richard Wiley–carried on the family business in the third generation. Richard's brother, Edgar, also worked for a time in the Studios. Fourth-generation family members to work in the Studios are Horace Judson's three children: Cynthia Jane, Douglas, and Walter; Walter's wife, Karen; and Leora Marie Rundstrom and her husband, Carl Black. Walter and Karen Judson now own The Judson Studios. Working with them are their sons, Bill and David. Their daughter, Lisa Ann Judson-

Connelly, previously worked at the Studios. Douglas's son, Earl, also has worked at the Studios.

As Walter W. Judson once declared, "There's always been a strong-willed Judson with a total dedication to stained glass."

2. Artists and craftsmen working at The Judson Studios in 1997

Writing more than sixty years ago, the great stained-glass designer Frederick Wilson described the workers at The Judson Studios as highly trained craftsmen from every corner of the globe. Their cooperative efforts, he said, resulted in "an inspired expression of beauty." His words are as applicable today as they were in 1931.

Barbara Gawronski, who recently joined the Studios as an artist, earned her master's degree in painting and graphic art at universities in Gdansk and Krakow. She was attracted to stained glass by the intensity of its colors and by the beauty of a centuries-old technique. An exhibiting artist, she uses various materials to create collages and assemblages. She tries in her work to give a feeling of eternity.

Douglas Judson, who heads the faceted glass department, began his career in stained glass in the same way as his brother: sweeping up broken glass from the floors of the studio. As a child he was attracted by the richly colored dalles that make up a faceted window, and for many years he has helped create those windows. The spiritual quality of stained glass helped influence his decision to study for the Episcopal priesthood, and he was ordained in 1971. He now divides his time between The Judson Studios and Saint Andrew's Episcopal Church in Torrance. "I have the best of both worlds," he says. "I have my church and I have my stained glass."

Abdelkrim Kebir, an artist and craftsman from Algeria, is deeply interested in the traditions and rich artistic legacy of Islam. Curiosity as to how Arabic calligraphy and other designs would look in stained glass inspired him to explore the art. He began an apprenticeship at The Judson Studios in 1984. About nine years later he met a Coptic iconographer who encouraged him to attend the Prince of Wales Institute of

Architecture, in London, and study with Professor Keith Critchlow, the author of *Islamic Patterns*. After earning a master's degree in Visual Islamic and Traditional Arts, Kebir returned to the Studios. One of his outside interests is carving gypsum plaques with intricate designs. Two of his prizewinning pieces are owned by the United States Embassy in Kuwait.

Arpad Maghera, a Hungarian from Romania, is an artist, painter, and designer. After graduating with a degree in fine arts, he taught in art school and was a free-lance artist, painting on canvas. He also did glass and metal decorations for the huge hotels being built throughout Romania. An old master–Julius Szappanos–trained him in stained-glass work, and Maghera opened his own shop in Arad, near the Hungarian border. He came to the United States in 1990 and began working at The Judson Studios the following year. He did all the painting and designing for the wedding chapel in Osaka's Imperial Hotel. Working at the Studios has enriched his knowledge, says Maghera, who believes an artist must always keep learning.

Paul Martinez credits his skill in the various aspects of stained-glass work to his studies in drafting and art. He began working at The Judson Studios in 1969, then left for an interval during which he had his own stained glass business. Paul takes special pleasure in final assembly of the window. Each section by itself is a jewel, he says, but the completed piece is an inspiration. In his home workshop Paul creates beautiful bowls of fused glass.

Clyde Reimann, the shop superintendent since 1989, has worked with stained glass for nearly fifty years. Much of his family also has been involved with stained glass. His grandfather was a portrait painter and a stained-glass artist in Milwaukee; his father was a glass painter who worked for a time at The Judson Studios. Clyde's daughter Sherri is an apprentice painter at the Studios, his son Robert is a part-time employee who helps with outside installations, and Robert's wife, Terry, works part time at the Studios as an artist. Clyde Reimann joined the Studios in 1956 as a master craftsman

after working a number of years in the stained-glass shop where he served his apprenticeship. "I've reached retirement age," he admits, "but I have no plans to leave. I enjoy the work too much."

Joseph Slater has an extensive background in stained glass. He began in 1978, one of the two craftsmen working in stained glass in an Indiana full-service glass shop. For a time he had his own shop in Indiana. After coming to California he worked in a design studio where he learned to facet glass. Faceting is one of his main responsibilities at The Judson Studios. Slater enjoys writing, and he has published several short stories. His interest in stained glass dates from his boyhood admiration of cathedral windows.

Hector Vargas, who became a craftsman at The Judson Studios in 1989, had learned carpentry at trade school but finds working with stained glass more challenging. Accomplished in all aspects of the craft, he especially enjoys using his skills for glazing and repairing old windows. It is a satisfying experience, he says, to find the right glass, follow the old painting style, and re-create a beautiful window.

In 1997 four young people were serving an apprenticeship at The Judson Studios, learning all aspects of the craft. Jorge Vidal was introduced to The Judson Studios by his brother, who worked for a time in the Studios. Angel Rementeria learned the rudiments of the art from his father, who has worked with stained glass for many years. Luis Porras began working part time at The Judson Studios while still in high school. Now a full-time employee, he also is working toward his AA degree, attending evening classes at a community college. Porras grew up with a love for all forms of art, including music and painting, and he is learning a respect for glass.

Sherri Reimann, apprentice-painter, comes from a family of stained-glass artists and artisans. Her father, who is shop superintendent at the Judson Studios, taught her to cut glass, cement, and do full-size cartoons. Even before graduating from junior high school, she held summer jobs in stained-glass studios. She always has had the ability to draw, and now is perfecting her techniques of painting and tracing.

A CENTENNIAL ROSTER

Although officially neither an artist nor a craftsman, secretary Gwen Mahjoubian speaks the language of stained glass. A friend of the Judson family for thirty years, she worked part time for Horace Judson. For ten years she has worked full time, acting as receptionist, keeping the books and accounting records, and handling invoices and proposals.

3. WORKERS OTHERS THAN FAMILY MEMBERS EMPLOYED BY THE JUDSON STUDIOS SINCE ITS FOUNDING

The following list was compiled from company records, which unfortunately are not complete, especially for the early years of the business. (Who, for example, was Joe? Who was Kid? Who was Boy?) The Judson Studios regrets the omission of any names that should have been included, and welcomes information that might help fill in the gaps.

Leslie Abbott
Arthur A. Ahlroth
Enrique N. Alberto
Mr. Alexander
Albert Allwelt
Mr. Anderson
Mr. Angleman
Astrid Beck
Thomas Bellringer
George E. Berenyi
George P. Berenyi
Jean Louis Bock
Helen Bolinger
A. E. Brain
Robert F. Brammer
Van L. Bridgeman
J. J. Brown
Josef Bubetz
Bohdan Bucmaniuk
Daniel Burian
Ronald Burian
John Herbert Buttrud

Frank J. Cajigas
Pedro Calderon, Jr.
George W. Canfield
Antonio Caratachea, Jr.
Victor Cardet
Jae Carmichael
Mr. Carr
Amir S. Chafai
William J. Chandler
John Timothy Charlon
Lenora Ann Cimarusti
Earl E. Clibborn
Charles E. Clifford
Elroy C. Coberly, Jr.
Earl L. Cock
Leonard C. Cogswell
Mr. Coleman
Ira A. Cooper
John C. Coppage

Linda Ann Cox
Kathleen Jane Craig
Daniel M. Crowley
Patsy Rae Dailey
Agnes M. Davis
Arthur J. de Carufel
C. R. Densmore
Harry de Temple
John F. Dickin
Pete DiLorenzo
Virginia Ann Dismukes
Paul M. Dobinson
Ann R. Dodson
Ricardo M. Dominguez
Aaron Dunklin
Mr. Dyer
Carole A. Edwards
Chris Ellis
Joy Anna Emerson
Ina Fagan

129

Peter Farrell
Charles Findlay
Mr. Finley
Karel V. Fisher
Fergus D. Foley
Noel D. Foley
Oliver D. Foley
Patricia Barbara
 Foley
Kevin O. Fresh
Austin Gale
James R. Gangwer, Jr.
Mr. Gardner
Barbara Gawronski
Donald C. Gelder
William C. Gerber
Douglas R. Gibbs
Robert J. Gibson
Robert Gilman
J. Gleeson
Nora B. Goddard
Simon Goldberg
Conrad Gonzalez
David A. Goodson
Kenneth E. Grant
Lillian G. Gray
Hermine Gregorian
C. D. Grolle
Jean A. Gross
Boyd E. Guymon
Georgia H. Guymon
John E. Haines
Mark C. Haines
Lucie Hamel
Barbara Hansen
Stanley C. Hansen
Martin V. Hanson
Reginald V. Hart

Donald T. Hartwell
Mr. Harvey
Lewis J. Hatcher
Scot D. Haugaard
Walter F. Haywood
Eleazar Herrera
Mr. Heyte
Marjorie Hickman
Ralph H. Hickman
Rick L. Hitchcock
Mr. Hoffer
A. M. Hoagland
E. C. Hoagland
Tom Holland
Mr. Holling
Marian Hood
Mr. Howland
Mr. Husted
Charles E. Hyatt
Barbara Beth Jeffries
Helen H. Jex
Gordon Jones
Selma G. Karlin
George Kavanaugh
Victoria Kearney
Abdelkrim Kebir
Kathleen J. Keefe
Kelly Jean Kelter
Larry Kendall
Martin A. Kern
Kenneth Kerry
Marion Kerry
Jennifer A. Kersten
Jeffrey I. Kessler
Robert S. Kieffer
Frank V. Krstulja
Jack Kuttner
Eston A. Lawrence

Donald D. Lawson
Albian Lee
Gene-Paul Lemieux
Alfredo Leon
Juan A. Llabona
Lucile Lloyd
Mr. Lofford
Rosanna Lopez
Joseph R. Lupkin
Betty Jane
 McCormick
Ann Pope MacDuff
T. McGlinn
Mitchell A. McGuire
Javier Machado
Jeanne McNamara
Thomas McQuattie,
 Sr.
Carl A. McVey
Arpad Maghera
Gwen Mahjoubian
Robert Mansfield
Ricardo Marcos
Mr. Mart
Andrew L. Martinez
Lisa Martinez
Matthew E.
 Martinez
Paul T. Martinez
Herbert Meinke
John S. Melville
Jose A. Mendez
Mr. Mercer
Cornelia D. Merkel
Mauricio E. Moreno
Jack T. Morgan
Gaston Morineau
Willis V. Morris

Frank B. Mountain
Mr. Nekman
James A. Nelson, Jr.
Ellen M. Nerdahl
A. Newman
Linda Jean Nicola
John R. Noble
Gerardo Norris
Ronald F. Norris
Kathleen M. Oas
William W. Oas
Joseph J. O'Connor
Jun Ohnuki
Mr. Olsen
William H. Oppliger
James A. Parchment
Arthur Y. Park
Alfred J. Parker
Charles Parker
Wanda J. Patterson
James A. Pearce, Jr.
Jacqueline Jay Peery
Paul L. Phillips
Geno Piccoli
Robert W. Pollari
Luis Porras
Jack Powers
Emanuele Raffi
Carl A. Reimann, Jr.
Clyde Reimann
Robert Reimann
Sherri Reimann
Terry Reimann
Angel Rementeria
Edward J. Rey

Robert D. Rives
Hilda Robb
Mr. Robinson
Frances Rosener
Elaine M. Ross
Janice E. Ryder
Jerome F. St. John
Samuel Sanchez
Everett A. Sauder
Jerome A. Savage
William E. Scotten
Arlene Setinc
William Silverman
Eric A. Sisley
Joseph R. Slater
Harry Smith
J. C. Smith
William J. Smith
Arthur Smithberg
H. M. Smyrk
Maria Sotomayor
Philip Spaulding
Jennifer K. Steele
Jonathan Steele
Mr. Stevens
Irene I. Strickler
W. P. Sumner
Walter H. Swaffield
C. A. Taliaferro
Joan Louise Tapp
Derrick J. Taylor
John V. Taylor
Vernon C. Taylor
Hans Georg Teepe
Salvador V. Tello

Adrienne Thome
Charles E. Thompson
Thelma E. Thrasher
Mr. Ulrich
Hector Vargas
Juan Vasquez
Jorge Vidal
Julio Cesar Vidal
Richard R.
 Villagomez
Alfredo G. Villatoro
Daniel R. Vogl
Cindy E. Voorhees
Cynthia L. Vournas
John Wallis
Marlene V. Wathen
John Weidner
Keith West
Patrick E. West
Thaddeus C. Westall
George Whittaker
C. B. Wilcox
Edward B. Wilcox
Claus Willenberg
Elroy Wilson
Frederick Wilson
George L. Wilson
Lenore Joy Wilson
Trevor B. Wilson
Miss Wirtz
Cleo Gene Wolfe
Mr. Yocum
Robert C. Youngman
Michael L. Zapponi
Daniel Zimmerman

(Facing page) Lending library card issued to
W. L. Judson in London, Ontario.

A Selected Reading List

By William Lees Judson

"The Architecture of the Missions." Historical Society of Southern California *Annual Publication* 7 (1907-1908): 114-118.

"An Art Opportunity." *Out West* n.s., 5 (May 1913): 255-256.

The Building of a Picture. Los Angeles and San Francisco: Sanderson Publishing Co., 1902.

"A Desert Incident." *Overland Monthly* 2d ser., 30 (October 1897): 323-329.

"Early Art in California." Historical Society of Southern California *Annual Publication* 5 (1902): 215-216.

"Fine Art as a Learned Profession." *American Magazine of Art* 10 (December 1918): 59-61.

"How I Became an Impressionist." *Overland Monthly* 2d ser., 30 (November 1897): 417-422.

"Manifest Destiny." *Graphic* August 10, 1918: 10.

"A New View of Modern Art." *Graphic* January 1, 1918: 20.

A Tour of the Thames. Written and Illustrated with a Faber's B.B. by Professor Blot. London (Ont.): Advertiser Steam Presses, 1881.

About William Lees Judson

Burson, Mark Maurice. "William Lees Judson: 1842-1928. Southern California Artist." Senior Thesis, University of Southern California, June 1977.

James, George Wharton. "A Representative American Artist." *Twentieth Century Magazine* 1 (1909): 12-15.

____."William Lees Judson, Painter." *Out West* 5 (May 1913): 242-254.

Moure, Nancy Dustin Wall. *Dictionary of Art and Artists in California before 1930.* [Glendale, CA, Dustin Publications], 1975: 133-134.

The Judson Studios

Bittan, Joshua and William Judson. "The Sephardic Heritage Windows." *Stained Glass* 89 (Summer 1994): 115-116.

Brammer, Robert F. "Stained Glass. An Old Art Meets New Construction Opportunities." *Architect & Engineer* 209 (May 1957): 8-15, 23.

Hoover, Richard L. "The Judson Studios." *Stained Glass* 84 (Summer 1989): 121-128.

Judson, Horace. "A Stained Glass Craftsman Looks at the 20th Century." *Architect and Engineer* 191 (November 1952): 8-15.

The Art of Stained Glass

Brisac, Catherine. *A Thousand Years of Stained Glass.* Translated by Geoffrey Culverwell. Edison, N.J.: Chartwell Books, 1986.

Connick, Charles J. *Adventures in Light and Color: An Introduction to the Stained Glass Craft.* London: G. G. Harrap, 1937.

Cowen, Painton. *A Guide to Stained Glass in Britain.* London: Michael Joseph Ltd., 1985.

_____. *Rose Windows.* 1979. Reprint, New York: Thames and Hudson, 1990.

Divine, J. A. F. and Blachford, G. *Stained Glass Craft.* 1940. Reprint, New York: Dover Publications, 1972.

Halliday, Sonia and Laura Lushington. *The Bible in Stained Glass.* Morehouse: Ridgefield, Conn., 1990.

Judson, Walter W. *Stained Glass: A Step-by-Step Guide.* New York: Galahad Books, 1972.

Lee, Lawrence; George Seddon; and Francis Stephens. *Stained Glass.* New York: Crown Publishers, 1976.

Reyntiens, Patrick. *The Beauty of Stained Glass.* Boston: Little, Brown and Co., 1990.

Stained Glass Association of America. *SGAA Reference and Technical Manual.* 2nd ed. Lee's Summit, Mo.: Stained Glass Association of America, 1992.

_____. *The Story of Stained Glass.* [Lee's Summit, Mo.]: Stained Glass Association of America, 1984.

"Stained-Glass Windows." *Metropolitan Museum of Art Bulletin* 30 (December 1971/January 1972): 97-150.

Theophilus. *On Divers Arts. The Foremost Medieval Treatise on Painting, Glassmaking & Metalwork.* Translated by John G. Hawthorne and Cyril S. Smith. New York: Dover Publications, 1979.

Wilson, H. Weber. *Great Glass in American Architecture. Decorative Windows and Doors Before 1920.* New York: E. P. Dutton, 1986.

An invaluable source of information on artists, craftsmen, history, materials, and techniques can be found in a quarterly published by the Stained Glass Association of America: 1907-1925 as *Ornamental Glass Bulletin*, 1925-1931 as the Association's *Bulletin*, and since 1931 as *Stained Glass*.

(Facing page) Students in 1913 outside the College of Fine Arts building (now home of the Judson Studios). *Courtesy of Virginia Neely.*

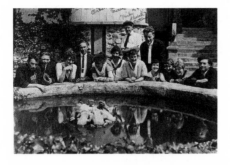

Index